TAMPA BAY
BEER

A HEADY HISTORY

MARK DeNOTE
FOREWORD BY RICHARD GONZMART

AMERICAN PALATE

Published by American Palate
A Division of The History Press
Charleston, SC 29403
www.historypress.net

First published 2015

Manufactured in the United States

ISBN 978.1.62619.873.9

Library of Congress Control Number: 2015941630

This book is dedicated to Goose, the light on my sundial, the ever-curious MED. Looking at you is seeing everything that is good and loving in the world hugged into one bundle of light.

Varyuvanyel, tenna ilyë eleni nar vanwë.

CONTENTS

CONTENTS

FOREWORD

The burgeoning craft beer movement follows in the greatest democratic and romantic traditions of this country. I imagine entrepreneurs, sometimes working in their kitchens or their garages, producing a distinctive lager or individual ale. I think of their faces when they realize they've absolutely nailed it—"Here, you gotta try this!" Of course, some of the best brewers eventually outgrow those humble beginnings and open microbreweries, brewpubs or regional craft breweries.

Where once there was near-monolithic control of the beer market, craft beer is now 11 percent of the U.S. beer sold and 19.3 percent by dollar. While overall beer sales increased only by .5 percent in 2014, craft beer sales increased by 18.0 percent (22.0 percent by dollar). Even the White House is producing its own beer.

Brewed in smaller quantities, craft beer offers freshness, distinctive taste and originality. There are 3,418 craft breweries in the United States and more than 75 craft brewers just in the state of Florida. The Tampa Bay area has been named one of the top ten craft beer markets in the United States by several national publications.

Beer making is in my family's heritage. The founder of our Columbia Restaurant Group, Casimiro Hernandez Sr., came to America from Cuba,

seeking the American Dream and a better way of life for his family. He began work at the Florida Brewing Company on Fifth Avenue in Tampa's Ybor City. As part of the brewing process, they used water from the Magbee Spring a few miles away.

Just as railroad companies used to open resorts to encourage use of their product, breweries opened saloons. And that's how our restaurant began. The Saloon Columbia opened on December 17, 1903 (the same day the Wright brothers took flight), with my great-grandfather as manager. At one point, according to a book on the Columbia's history, saloons occupied all four corners of that intersection at Twenty-second Street and Broadway (now Seventh Avenue).

In 1905, Hernandez Sr. bought the restaurant adjoining the saloon and opened the Columbia Restaurant, which in 2015 celebrates 110 years of continuous family ownership. And now our family's newest restaurant, Ulele, sits next to that spring (renamed Ulele Spring a few years ago) in Tampa Heights.

As soon as I saw the impressive space formerly used by the City of Tampa cable TV studio, I knew I had to put a brewery there. It's a perfect fit for the hyper-local focus of what we do at Ulele. And it is a connection to my family history and heritage. (You may have noticed that our family encourages and celebrates these connections that reach across generations.) A little later, I decided to expand the brewery there because I was so excited. We have big plans both for the brewery and the adjacent beer garden.

Our award-winning 2,100-square-foot Ulele Spring Brewery creates fifteen U.S. barrels (465 gallons) per brew. We offer fresh-brewed lagers and ales using only the finest malted grains, hops, yeast, fresh fruit and locally sourced honey. We create these beers using American equipment with no artificial preservatives of any kind. Just as we continue to serve food from recipes passed from generation to generation in my family, we're continuing another family tradition of making local beer that is as distinctive as our Tampa home.

Cheers!

–RICHARD GONZMART

PREFACE

When I was approached to write this book, I was amazed that it had taken so long for such a guide to be written about Tampa Bay. While writing my first book, *The Great Florida Craft Beer Guide*, Tampa's craft beer scene changed immensely over the course of the years it took to finish. I am constantly amazed at my good fortune to live in the city that is undoubtedly blazing trails and making inroads for craft beer throughout Florida.

I have lived my life between the two coasts of Central Florida, and while I love this state, I am proud to call Tampa Bay home. Put simply, Tampa has its rough spots, but by and large Tampa Bay embraces beer as a part of retelling its storied past and as a way to celebrate the jobs and the gains that the future promises. What started off as an area that was owned by the biggest brewer time and time again is now a haven for the brewer with a dream. Tampa Bay first embraced Belgian-style farmhouse ales from Tarpon Springs as Saint Somewhere Brewing was born in the mid-2000s. Once rural areas like Pasco County and Plant City now boast craft breweries serving up local beer to locals. Tampa Bay, more than any other area of Florida, quite simply embraces the vigor, vivaciousness and conviviality that come with craft beer.

Craft beer in Tampa Bay represents the quintessential American Dream— the one where someone with a recipe, a work ethic and an aspiration can start with an investment and build a business. That is one of the reasons why I keep supporting and working with the area's craft breweries—for many, this is the actualization of their dreams. Whether it's the homebrewer Greg

PREFACE

Rapp, who wanted to turn pro and build a brewery; the Doble family, who thought that Tampa Bay deserved better beer when no one else was making it; or the Bryant family of Dunedin, who started out building a place for area homebrewers to refine their craft, what they all have in common is the support of family, community and integrity within the scope of their art.

Cheers to the Tampa Bay craft beer community. Thanks to all of you for sharing your stories and your art. I have tried my best to do it justice within these pages.

ACKNOWLEDGEMENTS

My wife has to be the greatest person I have met in real life. From the all-nighters to the crazy ideas, I owe a deep thank-you to her, and I hope putting it in print forever is a start to showing my infinite gratitude. I also thank my awesome family for their support of my desire to write and publish books about beer. You are always with me. To CE, ME, LA and ADP, you motivate me each day. Everyone in my family has been so supportive of this endeavor, and I love each of you for it.

A huge thanks to Jan and Marty Cummins, who sent me on my first writer's trip and helped me fall in love with nonfiction, writing, traveling and the road. Thanks to both of you, as well as your wonderful family.

Thanks to Richard Gonzmart for writing the foreword to the book. I hope I have done your words justice.

Thank you to all of those fine businesses that support Florida Beer News. I could not write books without your help.

Thanks to all of the folks who spent time talking to a relative stranger who e-mailed or called them out of the blue, sometimes showing up late and treating him as well as you did. Thanks to Joey Redner, Justin Clark, Russell Breslow, Jeremy Joerger, Barry Elwonger, Matt Powers, Jeremy Denny, Ricky Wells, Nick Streeter, Josh Brengle, Wayne Wambles, Geiger and Hannah Powell, Toni and Anthony Derby, Khris Johnson, Nate Stonecipher, Steve Duffy, Kent Bailey, Casey and Jules Hughes, Teri Parsons, Zeus Cordeiro, Mike and Leigh Harting, Darwin Santa Maria, Matt Cornelius, Jorge Rosabal, Dave Doble, Tom Barris, Jay Dingman, Tom Duffe, Justin Stange,

ACKNOWLEDGEMENTS

Devon Kreps, Mike Lucacina, Megan O'Boyle, Brian Fenstermacher, Doug Dozark, everyone at Cycle named Eric, Tom Williams, Brian Howard, Kevin Lily, Bill Knoedelseder, Josh Aubuchon, Luke Kemper, Brandon Nappy, Andy Bielecki, Charlie Meers, Cortney Curtis, Dale Swope and all the souls I have met in my travels.

Thanks to the folks from the original Tuesday night tastings; those made a big difference to me. To Dave Franich, Sebastian Jadot, Ben Romano, Ryan Dowdle, Gary Kost, Kevin and Kathryn Kieffer, John Watts, Mark Tuchman, Matt Rego, Paul Unwin, Jason Carter, Troy Ely, Zack Shuster, Greg Cotner, Shaun Shaut and all the fine folks I have forgotten in print, please know that I am very grateful for your cheers and kind words.

To all of the young breweries that I mention, I appreciate your time and help and wish you the utmost luck as you grow. I look forward to many more visits to come.

TAMPA'S CRAFT BREWING HISTORY

THE ERA OF BLACK DRINK: FLORIDA'S FIRST BREWS

The first brewers to ferment beverages in Tampa did not use steel tanks, well pumps, brick walls or any of what would become the tools of the trade. The first brewers in Florida were the native tribes who fermented ceremonial beverages for trade, everyday life or religious rituals.

While the history of craft beer traces its roots back more than one hundred years, the first to make fermented beverages in the Sunshine State did so without the aid of machinery and cereal grains. Florida's native tribes produced varieties of a caffeinated drink called "Black Drink" many years before Fort Brooke, or Tampa, was imagined. Black Drink stands as ancestor to Florida's modern fermented beverages. While beer ferments from grains, Black Drink would have been brewed more like a modern gruit. Gruit, like Black Drink, is more a drink of utility than of luxury. Black Drink was chosen for its ceremonial and purgative properties, despite the regular usage of the drink. Some of the native tribes of Florida made Black Drink out of the leaves of the yaupon holly plant, harnessing the natural caffeine within—the leaves, tested in 1883, were found to be 0.27 percent caffeine. Imagine this beverage to be a lot like modern coffee or tea, except that when left out or intentionally fermented, Black Drink would yield alcohol in addition to its normal caffeine kick.

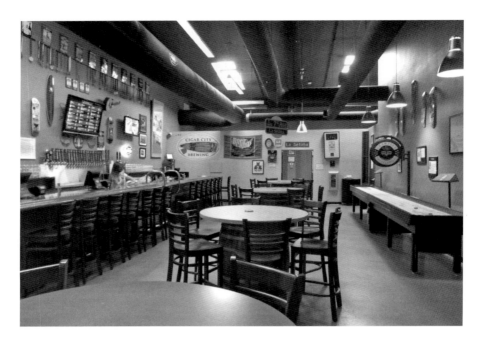

The Cigar City Tasting Room during a rare quiet moment. *Author's collection.*

Black Drink's origin goes back to the story of how the Creek tribe migrated to the southeastern United States. In stories told to government officials at the turn of the twentieth century, the Creeks received Black Drink from a legendary tribe (the Palachucolas), who told them that their hearts needed to be white and that their bodies must show proof that their hearts were white. French explorer Jean Ribault and Spanish explorer Pánfilo de Narváez also report tasting Black Drink during their contact with the native tribes on their expeditions.

Contrary to modern beverages, however, Black Drink was not recreational; it was usually ceremonial or cultural, often harnessing the purgative powers of the plant if not the caffeine. In records dating back to 1776, the Creek people would brew the drink by toasting the yaupon holly leaves and making a decoction of them, even allowing a froth on the beverage. Black Drink was so strong that only men were allowed to drink it, at least in public. When it came to religion, the brew could be used as a purgative or as a hallucinogen, depending on the occasion. Several (mostly minor) variations on making the drink were reported between tribes.

Black Drink was more than just part of religion or the stuff of life, however; it was also an item of commerce. In papers dating back to the nineteenth

century, Black Drink was found among native tribes far from the growing places of the cassine tree. The value of the drink outside of tribes that kept records is unknown, but its presence is undeniable. Black Drink was so much a part of the native culture that the famous Seminole leader Osceola's name (in the Muskogean language family) means "Black Drink singer."

THE ERA OF LAGER BEER: THE FIRST COMMERCIAL SUCCESS

Once colonization and fort building began among the areas of Florida, it was not long after the onset of the Seminole Wars that a government outpost was built on the Tampa Bay in January 1824. The outpost was dubbed "Fort Brooke" after the commander in charge, Colonel George Mercer Brooke, and a garrison of soldiers soon came to know and dislike the Tampa Bay area. While soldiers usually aid in the development of beer, in this case their contribution would be limited to their water source. The soldiers who built Fort Brooke would use a local spring for watering their horses and the outpost, and that spring, dubbed Government Spring, is where the story of Tampa Bay's craft beer scene truly begins.

Once Government Spring was harnessed for the troops' water, the city grew along with usage of the water source. Government Spring, in its lifetime, would evolve from a life-giving spring to a swimming pool, a water source, a freezing-cold income generator and a fermentation starter before the twentieth century began.

As Fort Brooke began to grow into its own, the usage of Government Spring changed hands. The troops at the fort, about two miles from modern Ybor City in the densely pine-covered lands, would continue to be the dominant users of the spring until the fateful day when an area of Tampa would come to be ruled by one man and the life-giving industry he brought to Tampa. Don Vincente Martinez Ybor brought to Florida an industry that would forever change Tampa's destiny. His cigar factory would bring workers from Spain, Cuba and Key West to live, work and drink in what was then called "Mr. Ybor's City." One of the first roads that Ybor built was to the same spring that had previously given life to the troops. In an article about Government Spring, Tampa historian Tony Pizzo wrote that "[a] corduroy road was built from the fort through the salt marshes of what is now the Ybor Estuary to a large spring at the present site of Fifth Avenue

and Thirteenth Street." After becoming a leading city of industry with the buildup of the cigar factories, Mr. Ybor and his advisors smoked around the idea of a new type of business, one that would help keep workers' money in the city and would also give laborers a way to socialize with a creature comfort that many enjoyed at home: beer.

The journey from backwater military outpost to cosmopolitan city of the South was neither quick nor easy. In the early days of Tampa, the average laborer was in the United States to work and support his family, many of whom were back home in a different country. Within the confines of the workers' tiny apartments, a man could lose his mind. That was the problem that the Ybor City Brewing Company would seek to solve as Mr. Ybor's inner circle gathered to draw up building plans.

Pre-Prohibition Tampa was seen by many as a rough-and-tumble town and one that had many saloons. The idea of a saloon developed from the idea of a salon over in Europe: a place where men could discuss ideas and opinions over a libation or two and push forward society while recreating at the same time. Tampa had many saloons, though. The issue at hand was not the proliferation of saloons but rather the lack of customers to sit on stools and, most importantly, spend money. Competition between saloon owners became fierce, and rents only got higher for those men who tried to keep their businesses afloat. Enter St. Louis and Milwaukee's brewing elite. Having the technology of refrigerated railcars, the major breweries were the only ones that could ship beer miles and miles to a city outside the state. When these breweries descended on Tampa, they

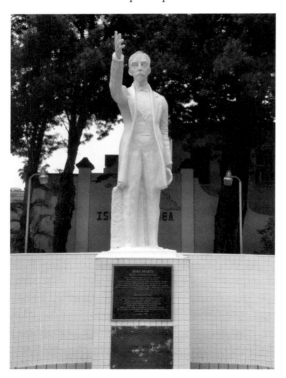

The statue of Tampan and Cuban orator Jose Marti at Jose Marti Park—a piece of Cuban soil in the heart of Tampa. *Author's collection.*

were all too happy to help offset saloon owners' bills, replace expensive lights and fixtures and even pay their rent in some cases. The only thing that these breweries and their reps would ask for in exchange was consideration in the form of dedicated tap handles. The saloon owners would, in many cases, exclusively pour a sponsor brewery's beer, creating a tied-house situation—one brewery's beer was served exclusively in that bar, and it would be considered "tied" to a particular brewery (to solve this situation, distributors were created after Prohibition).

IT WAS IN THIS RUGGED landscape that the cigar company owned by Don Vincente Martinez Ybor entered into the world of commercial brewing. Mr. Ybor's right-hand man, Eduardo Manrara, signed articles of incorporation, along with four other gentlemen, for the Ybor City Brewing Company on April 29, 1896. (These papers are still extant and visible, albeit worse for wear.) Mr. Ybor himself could not sign the papers because of the onset of health problems that would soon cause his death. The purpose of the business was "the preparation of malt drinks and to deal in such [business] as pertain to the workings of a brewery and of the power dispense of the same." The capital stock that the company began with was $150,000 (in 1896 dollars). The Ybor Company was backing the brewery with sizable and significant cash, and the only businesses that stood to lose from this were the big breweries of St. Louis and Milwaukee, all of which were trying to gain a foothold in Tampa.

Brewing interests outside Florida took to city meetings and various public forums to stop the Ybor City Brewing Company from being built. Mr. Manrara was so worried about these efforts that he and the board changed the operation's name from the Ybor City Brewing Company to the Florida Brewing Company, thus showing a far-reaching ambition beyond the limited view of the other nonnative breweries. Florida had such a hot climate that the type of beer in vogue during this period was the light lager. This style of beer comes from Germany and is very easy-drinking in a hot climate like Florida; more importantly, it is best served fresh. The larger breweries would ship their beer in via the refrigerated rail car and straight to the bars and shops, but because of the distance covered (beer would have to be shipped from the home state breweries in Milwaukee and/or St. Louis), the beer could never be as fresh as the beer brewed down the block in Mr. Ybor's City.

That capital stock guaranteed a top-of-the-line brewery with the latest equipment and brewing techniques in an area that was the most inhospitable to some of Florida Brewing's most popular beers. The brewery was brewing

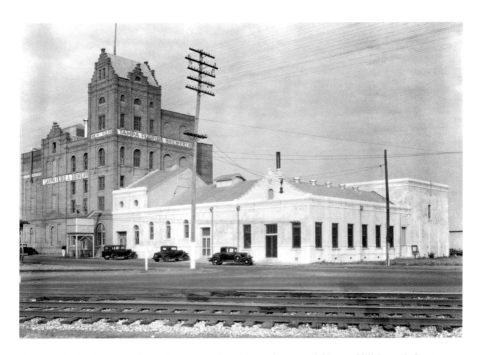

Tampa Florida Brewery Inc. after reopening, 1936. *Courtesy of Tampa–Hillsborough County Public Library System.*

lagers, beers that must age in a cold environment for up to several weeks before they are ready to serve. In the present day, brewers have technologies that aid in overcoming Mother Nature's best attempts at beer spoilage, but in 1896, at a time when horses and carriages were still used and electricity was just being installed around cities, this proved challenging. The answer was twofold: insulation and technology. The brewery was not the only business on the grounds of the Florida Brewing Company. The company also had an ice works and a bottling plant.

The company began with insulation. There were two sides to the brewery: a hot side and a cold side. The two sides were completely sealed off; in fact, the brewery building is now a law firm, and Dale Swope, the building owner, swears that the former cold side of the building is consistently several degrees colder than the former warm side. Next, the company added steam-driven ammonia compressed refrigeration to keep cellars at a necessary temperature for fermentation. Gravity was also employed, sometimes for help and sometimes for hindrance, as beer was occasionally pumped back upstairs for various reasons. Grain would make its way to the top of the building and from the bins

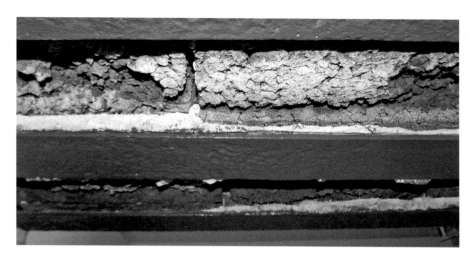

Cross-section of original insulation, Florida Brewing Company (now Swope Rodante, PA office). *Author's collection.*

A side view of the Tampa Florida Brewery. *Courtesy of Tampa–Hillsborough County Public Library System.*

to the malt cleaner, hopper or mill; down a flight of stairs to various tanks; and down another flight to the mash tun and boil kettle, finally ending up on the ground floor for racking and cellaring.

The brewery proved successful. Regardless of the measure, the brewery surpassed expectations. The first year of the brewery operation, it produced fewer than four thousand barrels of lager. In just the second year, that number tripled to fewer than twelve thousand barrels. This was a leisurely pace, since the brewery could produce up to three hundred barrels of beer per day. The cost of running the brewery could be paid if the brewery produced twenty barrels each day. By 1911, the brewery was producing one hundred barrels per day. During a Labor Day parade in 1900, the brewery entered a float that served beer and filled it with one hundred barrels of lager. The float gave beer away until the end of the parade route, which proved the end of the float as well—the driver and residents had consumed all of the beer during the course of the sunny celebration. By 1899, the brewery was preparing beer for export to Cuba to meet the massive demand there. All of this prosperity would allow the brewery to make the curious purchase of distillation equipment in 1909.

THE ERA OF NO BEER AT ALL

All of this prosperity was not to last, as the Volstead Act became the law of the land. Residents recall a massive party to celebrate the end of intoxicating liquors. The next day, not a trace would remain. This provided a great cover story to convince the world that Tampa was participating in Prohibition. Tampa, true to its pirate past and the liquor-loving cultures that formed the city, made sure that these staples were available.

Prohibition raids happened all over Tampa. The Tampa–Hillborough County Public Library Photo Archive has several images of distillation equipment being smashed, beer being poured out and citizens being arrested for these crimes. In 1927, the Florida Brewing Company was raided, securing 12,600 gallons of beer with a rating "according to chemists, ranging from .041 to three and one-half per cent." While less than 0.50 percent alcohol by volume (ABV) beverages were legal, 3.50 percent beverages were not. The brewery had reportedly been making money selling a near-beer malt beverage called "Roby," which is "Ybor" spelled backward. There is also the matter of the mysterious distillation equipment and its use. Local legend holds that there are tunnels beneath Ybor City that lead from the Florida Brewing Company to the speakeasies held by local gangsters. (Local legends are the only source—if these tunnels exist, they have not been reported found as of May 2015.)

If Prohibition came on quickly, it left slowly. While much of the rest of the country was living in the throes of the Cullen-Harrison Act of March 1933, which legalized beer up to 4 percent ABV, Florida's legislature refused to convene a special session. Floridians would have to wait until May 1933 to legally drink beer again.

THE ERA OF LA TROPICAL

With Prohibition in the rear-view mirror, Florida's largest brewery was ready to emerge like a sapling that had weathered the winter, but ownership felt that a face-lift was in order. After Prohibition, the Florida Brewing Company was recommissioned as the Tampa Florida Brewery Inc. With a new brewery comes a new flagship beer; summing up Tampa, the city's Latin roots and a hotter-than-Hades climate in one name, the staff chose La Tropical for the flagship lager. La Tropical is the cash cow that led Tampa Florida Brewery Inc. to the heights of prosperity in the years after Prohibition.

La Tropical became the name of the brewery's many different styles of beer. Ale, lager and bock were all brewed under the La Tropical brand.

Modern exterior of Swope-Rodante Law Firm, originally the Florida Brewing Company. *Author's collection.*

For a time, the brewery would make a beer called FLA 6 (and also AL 6 and GA 6 for the same beer), noting the alcohol content of the beer and where it was intended to go to market. After 1949, those brands were retired, and La Tropical ruled the roost. Adjustments were made, and the brewery began to move most of its products almost exclusively into bottles, phasing out most of the beer on draft. As technology moved on into the 1950s, the brewery moved to cone-top cans (a form of aluminum can that is capped like a bottle).

Tampa Florida Brewery Inc. experienced unprecedented growth and prosperity in the years following the ratification of the Twenty-first Amendment. From the 1930s to 1941, the brewery sold about twenty-four thousand barrels of beer each year. In 1942, sales jumped to forty-eight thousand barrels, and in the postwar boom years, the brewery achieved its highest production ever at about eighty thousand barrels each year from 1944 until 1947. Sales then began a steady decline after a number of new factors came into play.

While the brewery did the best it could to keep up with demand and technology, other unforeseeable factors crept into Tampa Bay, shaping the fate of the first brewery.

THE ERA OF SILVER BAR

As the sun of Prohibition set on Tampa, Tampa Florida Brewery Inc. was not the only one eying a new era of business prosperity. Shortly after Prohibition, the former El Sidelo Cigar Factory of West Tampa was purchased by the DeSoto Brewing Company with the intention of turning it into Tampa's newest brewery. The *Tampa Bay Daily Times* covered the business, and the brewery bought large advertising in the paper to broadcast its facility featuring the latest technology and a highly skilled brewer using a "German process." Dan Arias, president of the brewery, had his photo in the paper wearing a large bow tie under his chin—lots of pomp and circumstance. Due to mysterious circumstances, DeSoto disappeared as quickly as it appeared, going gently into the good night. DeSoto's memorabilia stands as a gem to collectors since hardly any of DeSoto's beer made it to market. The building stands abandoned to this day, on the verge of being condemned after sitting idle for decades.

Not every beer business was so unfortunate, however. In 1934, the Southern Brewing Company came roaring into Tampa's bars and bottle shops. Based in

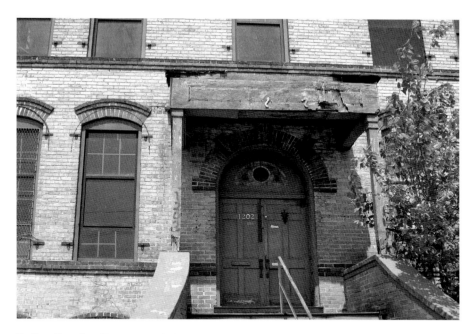

DeSoto Brewing Company's shell still exists at 1202 North Howard Avenue; it has suffered significant wear over the years. *Author's collection.*

a former warehouse on Zack Street, the brewery fitted a taproom on site with glass windows looking into the brewery so locals could watch initial brewer Walter Heuer hard at work. By this time, Tampa Florida Brewery Inc. was making twenty-four thousand barrels of beer each year, but the Southern Brewing Company could obliterate that number if it had the initial demand. It did not, and the brewery would chase (and occasionally surpass) Tampa Florida Brewery's numbers for the entirety of its existence.

The beers that made Southern Brewing famous were Silver Bar Beer, Silver Bar Ale, Florida Special, Old Tampa and Wurzburger Type (dark ale). Southern also had S-B Bock, a German-style strong ale that would debut around St. Patrick's Day as an early seasonal beer. Since there was not nearly the hype machine for beer that exists currently, S-B Bock would have a set release date of St. Patrick's Day, and the brewery advertised that fact with a 1938 ad of a sleeping goat with a sign that reads, "Do Not Disturb Until March 17th."

One aspect of the business at which Southern Brewing excelled beyond its competition was in advertising. It managed to advertise everywhere for its

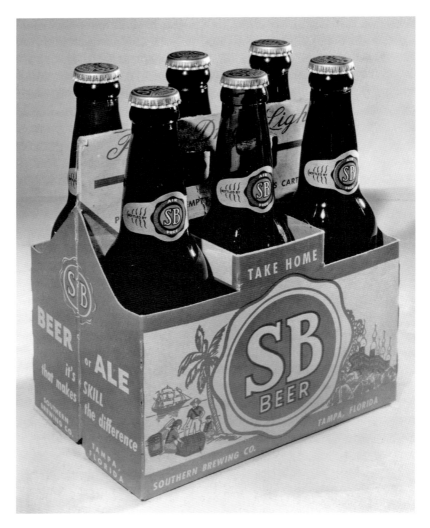

Six-pack of SB Beer, 1951. *Courtesy of Tampa–Hillsborough County Public Library System.*

products, from the traditional bars and restaurants to buses and billboards, even in segregated areas. Southern Brewing had white girls for the white bars and African American girls for areas that were segregated as black. Even segregation could not stop the Southern Brewing advertising machine.

That advertising machine would affect the brewery's sales numbers almost entirely for the better. The brewery advertised with lots of giveaways and merchandise around town. Many clocks still exist from the SB era, including one found at the old Tampa Florida Brewery Inc., ironically enough, and they

are collectors' items. Many beer trays were given to bars and restaurants that served SB Beer. Southern also knew how to capitalize on opportunities. The brewery received an invitation to sponsor a beauty contest in Atlantic City, New Jersey, and staff drove up the eastern seaboard in a car marked with the brewery logo, giving away beer and keepsakes the whole way north. The only downside of the Southern advertising machine came by way of a cease and desist notice given to the brewery by the Walt Disney Company. Apparently, some of the SB characters resembled Snow White's Seven Dwarfs a little too closely for Disney's tastes. Aside from this brief stumble, the Southern advertising department kept the brewery's name ubiquitous in print and on the radio waves.

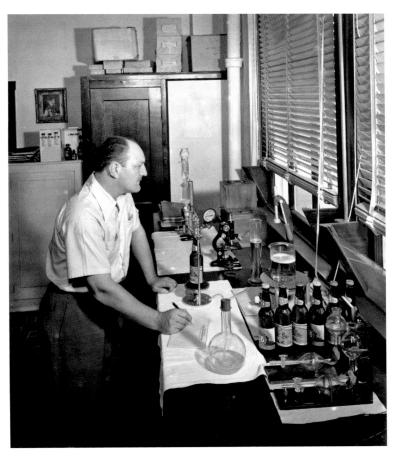

The brewer of SB Beer checks the Silver Bar line of beers for quality. Note the various different bottles in the foreground on the counter. *Courtesy of Tampa–Hillsborough County Public Library System.*

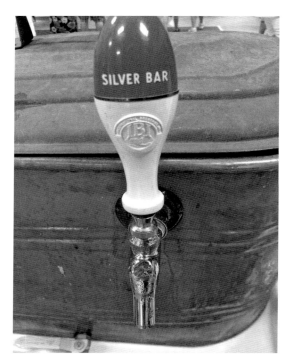

Left: An original 1960s Silver Bar tap handle maintained by Coppertail Brewing Company. *Author's collection.*

Below: Bottling machine at Southern Brewing Company, 1955. *Courtesy of Tampa–Hillsborough County Public Library System.*

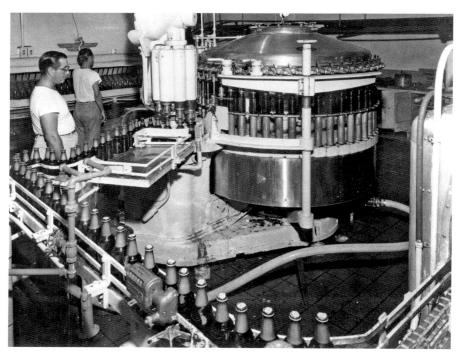

While Southern Brewing was in competition with Tampa Florida Brewery Inc., there were plenty of thirsty drinkers to go around. Southern Brewing worked at about sixty thousand barrels per year in the 1930s and 1940s, but once the postwar boom emerged, combined with the fruit of the advertising gains, the brewery sold upward of ninety thousand barrels of beer each year from 1943 to 1947. After those boom years, the brewery numbers would decline until a new problem emerged, one that would spell the end for brewers the size of Southern Brewing and Tampa Florida Brewery Inc.: automation.

THE ERA OF ST. LOUIS BEER

While Budweiser and other major breweries had their eyes fixed on Tampa, they were never able to get a foothold in the area with the dominant local breweries so popular in the market. That benchmark changed with the tenure of Augustus Busch II, known as "Gussie," and his ambitious expansion plans into the Tampa market. This time, the Anheuser-Busch Company was looking to build more than a brewery to enter the Tampa market.

On the street that still bears the company name, Gussie Busch set out to build a project that had everything he liked about his company: beers, birds and beasts. In 1957, construction commenced on Busch Gardens, the elaborate brewery tasting room and animal park that still captivates a section of Tampa tourists. Busch himself would order the fifteen-acre park built surrounding the brewery, and he also traveled to Miami (where the birds were imported) to pick up the birds that would come to define the early history of the facility. Busch and his wife would take the train to and from Tampa, laden with birds on the return trip. The place would allow visitors to enjoy free beer among the birds. At least, that was the concept. The park opened in March 1959 and soon expanded to encompass seventy acres, including a simulated Serengeti environment with matching animals and the seemingly absurd addition of a Swiss House Restaurant. (The restaurant was actually a replica of the one Busch's wife's family owned in Lucerne.) Busch Gardens would grow to be the second-largest theme park operation in the United States, a fact that led to a massive number of beer sales. Anheuser-Busch had invested $20 million in the opening of this plant, and the brewery already had to compete with Schlitz.

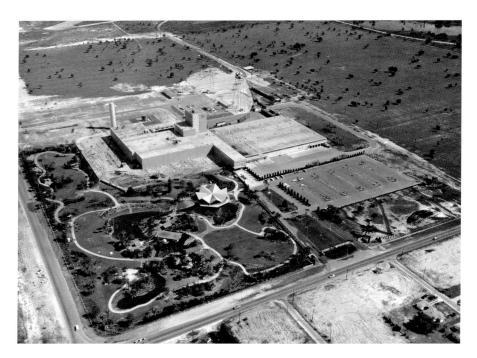

Aerial photo of the Anheuser-Busch Busch Gardens, circa 1959. *Courtesy of Tampa–Hillsborough County Public Library System.*

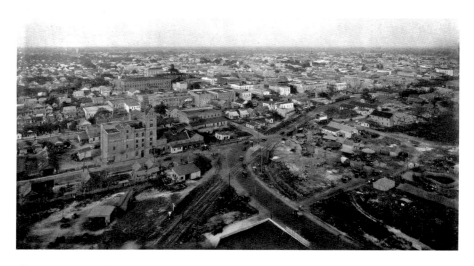

Historical photo of Ybor City from 1923, with Florida Brewing Company in foreground (largest building). *Courtesy of Tampa–Hillsborough County Public Library System.*

The Budweiser brewery that was built adjoining the theme park was a monolith of innovation and technology. As compared to the seemingly small brewers nearby, the brewery was using equipment that could can 1,000 beers in one minute with only one man running the machine. This was a stark contrast to Southern and Tampa Florida, which had machines canning 250 beers per minute run by three men. The smaller breweries could not keep up with the saturation that came from Budweiser, and the breweries began to fold starting in 1956, when Southern Brewing sold ownership to International Breweries Incorporated (IBI). IBI was a brewery owning group. The group continued making SB Beer and expanded the brewery to try to keep up with the dual threats of Anheuser and Schlitz. In 1961, after IBI also purchased Tampa Florida Brewery Inc., and in hopes of using both La Tropical and SB Beer against the twin goliath breweries, IBI closed Tampa Florida Brewery Inc. The equipment was sold off piecemeal to various industries. Two years later, Southern Brewing closed its doors for the last time, eliminating all the local competition for Schlitz and Budweiser for a few decades.

ANOTHER MAJOR BEER ENTERS

In the 1950s, Tampa was ready to receive its first new brewery, and this one would be one of the longest-lasting brewery structures in city history. In 1957, construction began on the Schlitz Brewery building on North Thirtieth Street, near the University of South Florida. The building would bring a national brand of beer to a new Tampa home and cause increasing headaches for entrenched Florida brewers.

Schlitz opened the plant and rolled out beer into the local market, beginning a wave of owners of the brewery but also a never-ending source of competition for local brewers. The Schlitz plant would outlive most of the Florida breweries until a time when Schlitz would run into competition, as well as financial and product quality issues all its own. In 1983, Schlitz would move away from the plant and sell it for $8.5 million to rival Pabst Brewing of Milwaukee. Pabst would not last in the building either. In 1986, Pabst idled 250 employees when operations in the building suddenly ceased. Pabst would run into financial problems and layoffs, selling the building at a $2.0 million loss to Stroh Brewing. Stroh would keep the brewery running until

the mid-1990s, when it would take a $500,000 loss to sell the building to its current owner, Yuengling Brewing Company, headquartered in Pottsville, Pennsylvania.

When Yuengling took the helm of the brewery, the company sent a message that the brewery was under new direction. Family owner Richard Yuengling Jr. hired back most of the original staff that Stroh had laid off. Yuengling has integrated the Tampa brewery into the fold and is currently one of the top producers of craft beer in the United States and the fourth-largest U.S. brewer overall (behind AB Inbev, Miller Coors and former building owner Pabst Brewing).

The Era of Ybor Gold

In the downturn for local beer, the years between the closing of Southern Brewing and the opening of another craft brewer in Tampa Bay were long and arduous. This was a time in the nation's history when a small cadre of national breweries was the only group in the game. Slowly, intrepid entrepreneurs began to poke their heads back into the market, like the first rows of people returning after a hurricane. The first significant attempt at making craft beer in Tampa came at the hands of a beer family from South America.

Humberto Perez—a businessman whose family founded and ran Cerveceria Regional, a powerhouse as the second-largest brewery in Venezuela—began his beer journey in the United States by founding the second company to showcase the name of Ybor City Brewing Company. By this time in history, states like California, Oregon and Colorado had seen a massive upsurge in the number of small breweries coming to market, but in the Tampa of 1994, Humberto Perez decided that he would invest in creating a beer in Ybor City, naming it for the city's namesake (the flagship beer was called Ybor Gold) and designing and taste testing the beer to pair well with Florida's staggeringly hot summers. Ybor Gold is an amber lager with toasted malt character and mild bitterness. At the outset, national breweries owned 99 percent market share in Florida, meaning that for every one hundred beers sold, ninety-nine of them were from major national breweries like Miller or Budweiser.

The Budweiser brewery associated with Busch Gardens closed in 1995, and the Pabst brewery had few signs of life left, so this was a

The exterior of former Ybor City Brewing Company, now the Stantec building in Ybor City. When the firm moved in, all brewery equipment was gone, but the classic Ybor Ciy Cigar Factory architecture remains. *Author's collection.*

promising time for a small brewer beginning in Tampa Bay. Perez could not have foreseen the issues that would steer his brewery out of business and into history. Little is public knowledge about the end of Ybor City Brewing Company. After some rumored disputes with distributors, and despite the fact that Ybor Gold was only one out of every hundred beers sold in Florida, Ybor City Brewing Company faced challenges getting beer to the marketplace. These problems would ultimately cause the brewery to close its doors just as the young company was on the verge of profitability. This was a tremendous setback to craft beer in the Tampa Bay Area, but the company had blazed a trail—one that other brewers and owners would tread, a trail that would lead to the twenty-first-century renaissance of craft beer.

Perez sold the brewery and closed its doors but allowed the brewery's recipes to live on via the Florida Beer Company of Cape Canaveral. Florida Beer Company currently owns the recipe for Ybor Gold and Calusa Wheat, as well as the lineup of beers that Ybor City Brewing Company brought to town in the mid- to late 1990s. In a nod to history,

Florida Beer Company also brews La Tropical (based on the Cuban recipe for the beer), as well as beers from Miami Brewing Company, Key West Brewing and other historical beers from Florida's breweries of this period.

THE ERA OF DUNEDIN AND TAMPA BAY

This time in history proved inhospitable to many young breweries, but not to young beer makers. The road was being paved by those Tampa Bay homebrewers who were inspired by their favorite beers and a sense of adventure. Michael Bryant Sr. had a love of homebrewing that he fostered in the 1980s and refined until founding the Dunedin Brewers Guild, which became the local homebrew club. Bryant then began, with his family, what would become Florida's oldest microbrewery in a small space in the city of Dunedin. Originally, Mike Bryant Sr. conceived of a space where homebrewers could get together and help one another while practicing their craft. This space would grow and endure to become Florida's oldest microbrewery (not to be confused with Florida's oldest brewpub, which is in Destin).

Across Tampa Bay, the Doble family has similar ambitions. John Doble and his son had designs in perfecting homebrews and making space to inspire others to homebrew, and the original homebrew shop space began in 1992, according to David Doble, Tampa Bay Brewing Company's current brewer and co-owner. The space on Waters Avenue was called the Brew Shack and stood as a haven for those looking to create flavorful beers on their own. The Dobles soon opened the original Tampa Bay Brewing Company in Ybor City in February 1997, closing its doors in September 2006 in order to move into their current location in Centro Ybor.

THE ERA OF TAMPA BAY BEER

When noted international beer writer Michael Jackson came to Tampa Bay in 1999 while writing his *Pocket Beer Guide*, the breweries and statistics that he observed and published are glaring in the light of modern Tampa

Bay craft beer. At that time, there were eight craft breweries operating in the Greater Tampa Bay area, the largest being Stroh, with an alleged capacity of 1.7 million barrels of beer produced in a year. Outside of that, Ybor City Brewing was chugging along at 70,000 annual barrels. After those two, the third-highest capacity brewer was the Sarasota Brewing Company at 2,000 barrels. Beyond that, the Hops chains of brewpubs were operating at between 400 and 800 barrels, with Dunedin Brewery and Coppers Grille and Tap Room bringing up the sudsy caboose at 364 and 100 barrels, respectively. While the Hops chain of brewpubs soldiered on in carrying the torch of flavorful beer, it, too, faded into the annals of history after strategic closings did not save the struggling company. It exists now as independently owned restaurants in the midwestern United States.

Florida's craft beer future is brighter than ever. With more than thirty breweries in the extended Tampa Bay area alone, Tampa is the beating heart of Florida's craft beer revolution. While it has not reached the fever pitch of Denver, San Diego or Portland (Oregon), Tampa Bay showcases an ever-changing array of fantastic beers from a diverse and ever-growing brewing community.

Tampa currently has several brewers of Belgian ales, from farmhouse ales to sours. Tampa also has brewers who pioneered a style of Berliner weisse that is exceptionally fine with Florida's hot weather and selection of tropical fruit. These beers, known fondly around the state as Florida weisses, showcase the tart style of a Berliner weisse tart wheat beer, with the color and flavor of whatever fruit the beer is showcasing. The extreme amount of fruit has led to deep hues not traditionally found in beer, like deep pink, green and orange.

No matter the brewery, the spirit of Tampa Bay's craft beer scene is ubiquitous. The brewing scene is dominated by brewers who realize that as of 2015, craft beer is just over 10 percent of national sales, and less than that in Florida. Considering that decades ago that number was zero, craft beer's progress is uncanny and only continuing to grow. Many brewers recognize other brewers and breweries as colleagues and not competition, promoting the scene, collaborating on beers and helping when asked. When 7venth Sun Brewery auctioned off its first pour, it was Cigar City owner Joey Redner who bought it. When a brewery like Angry Chair or Late Start is trying to establish a reputation, breweries like Coppertail and Brewers' Tasting Room let them brew on their brewing systems to help them grow. The expansion of Tampa Bay craft

beer begins with quality beer and flows outward into the community with that same generous spirit.

LEGISLATIVE ISSUES

Over the years that Florida has operated craft breweries, Florida's beer makers have also maintained some strange ties and breaks with the lawmaking body of the state. Simply put, the Florida legislature has a long history of generally not cooperating with craft breweries. Beginning with not allowing a special session to end Prohibition at the same time as the rest of the country, the Florida legislature has had a nasty habit of siding with lobbyists and a well-connected minority with much clout over the vocal majority of small business owners who run craft breweries.

In 1933, the rest of the United States was enjoying the end of Prohibition with the addendum to the Cullen-Harrison Act. Beer of 3.25 percent alcohol by volume was again legal. Soon thereafter, the Twenty-first Amendment to the U.S. Constitution repealed Prohibition nationwide. In Florida, change would come more slowly for two reasons. First, when Cullen-Harrison was approved, cases upon cases of beer were shipped to Tampa, but the people were not buying them en masse the way that the distributors predicted. Apparently, a fed-up body of citizens had taught itself to homebrew during the dry years. Then, when commercial beer returned, citizens shunned it because it did not have as much alcohol as its homebrewed brothers and sisters. Combine that with the lackadaisical approach to returning alcohol to legality and the brewers and legislators got repeal off on the wrong hoppy foot.

In another run-in with the law(makers), the Miller Brewing Company was considering building a brewery near Tallahassee in 1965. When Miller decided to build in Albany, Georgia, the Florida legislature felt jilted. It took a small push from lobbyists to get the legislature to approve a law prohibiting beer to come in any bottles that were not 8, 12, 16 or 32 ounces. While this does not seem to be a rough bit of legislation, Miller's beers came in 7-ounce "shortie" bottles that were very popular. Thus, Miller in this bottle size was banned from Florida. The unintended consequence of this law was the ban of bottles from craft brewers that came in so-called bombers, 22-ounce bottles, as well as bottles from overseas that were measured in the metric system, usually 11.2 ounces. All of these bottles were illegal, and this

restricted Florida so that only 648 brands of beer were available, whereas the rest of the country sold more than 4,300 varieties. It took an understanding legislative session in April 2001 to change this law and allow all bottle sizes 32 ounces or less.

Fast-forward to the rebirth of craft beer in more recent times. Now the legislature and the craft beer community are at odds over the sizes of bottles of take-home containers, or growlers. When seeking brewery-fresh beer, a growler is a container (made of glass, ceramic, plastic or aluminum) that the brewer fills at the bar or tasting room meant for fresh consumption. For the longest time, there was a law on the books that originated with Busch Gardens, allowing certain growler sizes as legal. While all bottle sizes are allowed at 32 ounces or less, as of April 2015, the size of a growler is still at issue. In craft beer, the industry-standard growler size is 64 ounces, or a half gallon. Florida is one of two states in the country that does not allow 64-ounce growlers by law. A 32-ounce growler (any number of them) can be filled and a 128-ounce growler can be filled, but a 64-ounce growler cannot. While several far-sighted members of the legislature have stepped in to help craft brewers change the laws, the lobby for the Florida Beer Wholesalers Association advocated against the bill. What was a one-sentence bill going into committee came out of committee with seventeen pages of changes and markups, including a provision that could have closed tasting rooms at all breweries and sent brewers like Cigar City Brewing searching to build new facilities outside their home state. That bill was scuttled in the House, thanks to the leadership of Dana Young, and in the Senate the brewers were supported by Senator Jack Latvala in their cause. Young and Latvala continue to advocate for the 64-ounce growler bill to pass, and hopefully 2015 will see this come to fruition.

TAMPA BAY BEER WEEK

One week out of every year, Tampa Bay's craft brewers go all in on teaming up for beer-centric events, dinners and tappings throughout the area, from Sarasota up to Hernando County and beyond. This week is anchored by Cigar City Brewing's Hunahpu Day, the one-day release of the brewery's lauded Hunahpu's Imperial Stout (an imperial stout aged on cacao nibs, ancho and pasilla chiles, cinnamon and Madagascar vanilla beans). This

The winners of the 2015 Best Florida Beer Competition. *Author's collection.*

Tampa mayor Bob Buckhorn and Barley Mow Brewing owner Jay Dingman pour the first beer of Tampa Bay Beer Week 2014. *Author's collection.*

Opposite, bottom: While bystanders look on, Florida Brewers Guild president Mike Halker (of Due South Brewing) taps the first firkin of Tampa Bay Beer Week 2015. *Author's collection.*

is the only day of the year when this beer is available for purchase at Cigar City. The week kicks off with the first firkin tapping at the Florida Brewers Guild Festival in Tampa and goes at breakneck speed until the end of the seven-plus-day-long celebration of all things craft beer.

Tampa Bay Beer Week's celebratory firkin, 2014. That year, each brewery in Tampa Bay contributed a beer that was blended into this firkin. As a sidenote, Saint Somewhere was the only brewery that did not make an IPA. *Author's collection.*

As much as the week has grown (with more than fifty events on certain days of the week in 2015), the inaugural week came to Tampa in 2012. With more than a dozen breweries in planning for Tampa Bay alone, Tampa's future is shinier than the copious beer tanks blazing to life to make the crafty elixirs.

MODERN-DAY GUIDE TO TAMPA'S CRAFT BREWERIES

PINELLAS COUNTY NORTH

Dunedin Brewery
937 Douglas Avenue, Dunedin, 34698
(727) 736-0606

The story of the Dunedin Brewery is the story of the Bryant family. The family opened the Dunedin Brewery in the namesake artsy town of Dunedin in 1996. Five years after serving its first pours, the brewery moved into the slightly larger facility from which it still pours today. The brewery-taproom is located one block off the Pinellas Trail and is housed in an old fire station, a property that can be aired out through bay doors when the weather cooperates. The brewery works with a Scottish theme, and its sword logo shows both its heritage and its theme of exploration and community.

Dunedin Brewery works to put on community events involving more than just the beer, though the beer does complement the event. The brewery hosts Stogies and Stouts every year in February, Spring Beer Jam in April, IPA Festival in June, Oktobeerfest and various other events throughout the year. Each of these festivals revolves heavily around Dunedin Brewery beer and is sometimes augmented with beer from friends of the brewery.

A visitor to Dunedin Brewery can expect to sample from the brewery's core lineup at any time. The brewery always has Celtic Gold Ale, a light,

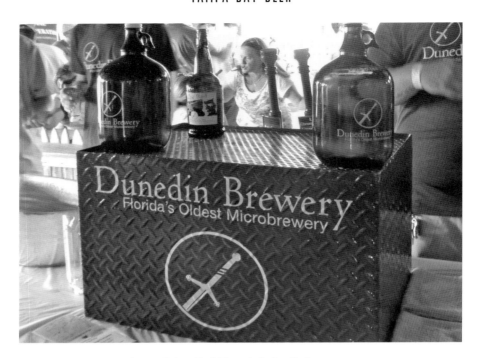

Dunedin Brewery pouring at Cajun Café Fest. *Author's collection.*

Dunedin Brewery's the Nook bar adds space and function to the interior space. *Author's collection.*

crisp ale; Apricot Peach Wheat, a fruity and sweet wheat beer; Red Head Red Ale, a hoppy, malty red ale; a hoppy and refreshing Pipers Pale; Beach Tale Brown Ale, an earthy and dry chocolatey brown ale; and Nitro Stout, the earthy and roasty year-round stout. Dunedin rotates through at least one seasonal each month and works to incorporate beer into the food (the menu underwent some changes in early 2015). The brewery staff also gets a chance to play around with some of the beers, including a few ephemeral treats that show up from time to time. Dunedin Brewery has also collaborated with neighboring 7venth Sun Brewery every year since 7venth Sun opened its doors, with each beer in this "Street Sweeper Series" different from the last.

Dunedin Brewery has two bars inside the actual brewery. There is the taproom bar, and around the corner is the Nook Bar, an extra bar with a small patio for more communal enjoyment.

Dunedin Brewery is focused on building community through quality beer and memorable events. Check the calendar of events for Dunedin Brewery, as some nights might simply be a drum circle at the brewery and some may be a great band performing a set during a beer release.

Tampa Bay Brewing Company
13933 Monroe Business Park, Oldsmar, 34677

In a leap away from the Ybor City brewpub that gained Tampa Bay Brewing Company (TBBC) its current reputation, the Doble family decided to build a brand-new, 17,400-square-foot brewery facility in the Oldsmar area, on the border of Pinellas and Hillsborough Counties. Staying true to their roots, however, the family included a tap house and restaurant in the plans for the new house of TBBC. The brewery will also upgrade to a thirty-barrel brewing system in this new complex, able to turn out more of the canned lineup of beers and creating as many as sixty new jobs for the area.

To break in the grounds, Tampa Bay Brewing Company hosted Bad Ass Beer Fest in June 2014, after the project was announced. The brewery invited Tampa Bay's craft breweries to come to the empty field and hold a beer festival for thirsty patrons, showing off the land before the project had begun. After a year's time, the brewery plans to be finished with construction, open to the public and pouring beers in early July 2015. Expect an outstanding array of beers to come out of this facility combined with award-winning

Tampa Bay Brewing Company head brewer David Doble and Southern Brewing brewer Brian Fenstermacher watch the awards at 2015 Best Florida Beer Competition. *Author's collection.*

favorites, especially after TBBC cleaned up at this year's Best Florida Beer Competition. TBBC won five medals in the 2015 competition, each for a different TBBC beer.

7venth Sun Brewing Company
1017 Broadway, Dunedin, 34698
(727) 733-3013

7venth Sun Brewing Company is a many-splendored craft brewery right down the street from neighboring Dunedin Brewery and Dunedin House of Beer Brewing. 7venth Sun is the northernmost leg of this Triforce called the "Beer-muda Triangle of Dunedin."

The company is a joint venture between owners Devon Kreps and Justin Stange. While Stange is head of brewing operations, Kreps does much of the marketing and the occasional brewing as well. By their powers combined, the two of them run the varied operations of 7venth Sun and manage to bring a diverse array of beers to the thirsty people of Florida.

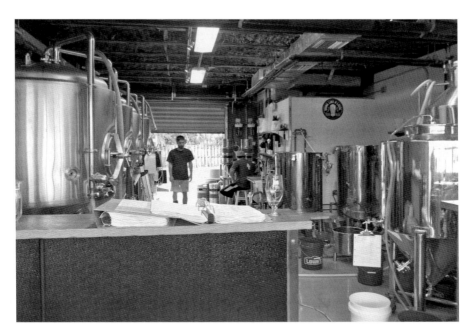

Above: 7venth Sun Brewery's brewing operation after expansion. *Author's collection.*

Right: 7venth Sun's fermenters. *Author's collection.*

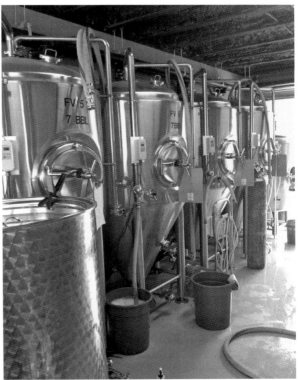

While 7venth Sun distributes kegs throughout Tampa and surrounding areas, some of its most unique beers are released in bottles exclusively. The bottled beers from 7venth Sun's sour project—like the legendary Cold Roses and Wizard Burial Ground, along with non-sour beers like Saison Caribe, Booty Wax Barley Wine and Solitary Confinement Imperial Stout—have all been sold in bottles out of the brewery. Cold Roses was one of 7venth Sun's first bottle releases, and since there were only just over twenty bottles, the brewery had to raffle off the right to buy one. All bottle releases since may

7venth Sun assistant brewer Mike Lukacina. *Author's collection.*

not have been as limited, but they have always come out of the brewery or a brewery partner's business.

7venth Sun's core beers start the lineup with the Time Bomb session IPA (a light and somewhat tropical fruit-forward IPA), Graffiti Orange Creamsicle Wheat Ale (like refreshing liquid orange creamsicle) and Intergalactic IPA (big herbal and fruity notes with lingering citrus bitterness). In addition to these core beers, 7venth Sun will always have something Belgian on tap, like some manner of saison, as well as something tart, usually a Berliner weisse with or without some manner of exotic fruit (anything from watermelon or plums to sudachi or beets).

7venth Sun Brewery also has the dubious honor of capping off Tampa Bay Beer Week by hosting the final major event: Hunahpu Hangover Day. This is a smaller-scale event than Hunahpu Day but involves 7venth Sun going all out on a tap list that will involve many limited and one-off beers made only for that event. While no bottles are sold during Hangover Day, 7venth Sun has drafts flowing all throughout the day, like 2015's tapping of 7venth Sun collaboration beers. These were all beers that Stange had teamed up with brewers from around Florida and around the country to make for this special day.

7venth Sun has plans for a new Tampa location to be released late summer/early fall 2015.

Dunedin HOB Brewing
927 Broadway, Dunedin, 34698
(727) 216-6318

HOB Brewing Company follows a similar business model to Citrus Park Brewery, which is also housed in a House of Beer location. The place is a craft beer bar that also makes house beers. Located on the same stretch of Dunedin as 7venth Sun Brewery, the HOB Brewing Company makes its beers in a warehouse located near the Dunedin Brewery.

HOB Brewing head brewer Caden Hjelseth is charged with bringing flavorful ales and lagers to the brewing establishment of Dunedin's House of Beer. The brewery's logo tells the story of the brewery itself: HOB Brewing is about enhancing the brewing community of Dunedin. Sunsets, dogs, pedestrians and a tandem bike all adorn the logo, showing off the lifestyle for which Dunedin is known.

Lagerhaus Brewery
3438 East Lake Road, Palm Harbor, 34685
(727) 216-9682

Lagerhaus Brewery is Palm Harbor's craft brewery that specializes in German-style and unique beers on any day of the week. Lagerhaus owner and brewer Franz Rothschadl has family that trace their heritage back to the winemaking traditions of Europe, and he also brings with him a wealth of knowledge about brewing English-, German- and Belgian-inspired ales and lagers.

In the days before he ran Lagerhaus, Franz was known as the brewer for Hoppers Grill and Brewery of Palm Harbor, and after a brief hiatus, he opened Lagerhaus to continue practicing the brewer's art that he loved so much in the small brewery overlooking the bar and restaurant.

The best way to keep up with Franz's variety of beers that he makes is through social media. The brewery's website has very basic information, but Franz sends out regular updates via social media and e-mail.

Lagerhaus does not have a true core lineup of beers, as Franz is usually changing up his selections, and he loves to surprise his loyal customers as

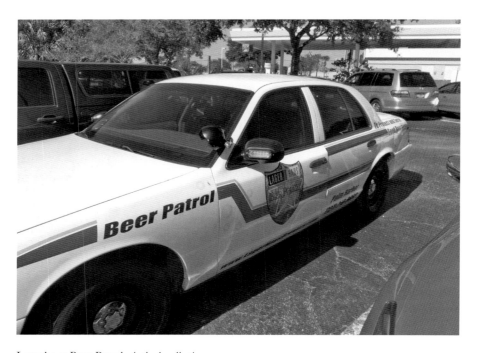

Lagerhaus Beer Patrol. *Author's collection.*

well as those just passing through. The Royal Bohemian Pilsner is one beer that Franz is especially proud of, as he won a gold medal for it at the 1999 Great American Beer Festival, giving Samuel Adams a silver medal after the Boston beer company had been dominant in the category for several years. In 2015, Franz is celebrating twenty years of brewing Bohemian Pilsner in the Americas.

A trip to Lagerhaus can be a tasty trip to many corners of the world. Expect to taste anything from a light hefeweizen to a fruity wheat beer or a salty gose. Just beware Franz's biggest beer: the .44 Magnum. This beer is a boozy monster that yields great taste but can produce unwanted truth telling better than Veritaserum or Sodium Pentathol. It weighs in upward of 20 percent alcohol by volume, so a little goes a long way. It's worth a sample.

If there remains any doubt about how seriously Franz takes beer, a walk through the parking lot will settle that. The Lagerhaus car is a retrofitted police cruiser with "Beer Patrol" on the side. At first glance, it appears that the police have stopped for lunch, but at further glance, it is apparent that beer has a place and a purpose at Lagerhaus.

Saint Somewhere Brewery
1441 Savannah Avenue, Unit E, Tarpon Springs, 34689
(813) 503-6181

Saint Somewhere Brewery is one of Tampa Bay's original craft breweries that emerged after some of the extinctions of the turn of the twenty-first century. Owner and brewer Bob Sylvester has perfected the recipes of his core offerings and has recently added a few new and surprising beers to his bag of tricks.

Saint Somewhere in general and Bob Sylvester in particular specialize in Belgian-style farmhouse ales. These ales are bottle-conditioned, and each batch can be slightly unique. Each bottle contains some yeast sediment, and the beer is still maturing in the bottle. Bob has made beers like these for years and, for a while, had to work at a day job in addition to brewing. When he was finally able to quit his day job and become a full-time brewer, he concentrated on perfecting his recipes.

Saint Somewhere has three core beers, as well as several seasonal and limited release beers. The oldest beer that Sylvester brews is Saison Athene, a farmhouse ale brewed with fresh rosemary, chamomile and black pepper. The beer is then bottled, and like every Saint Somewhere beer, a bit of wild

yeast is included for added complexity. The second beer in Saint Somewhere's lineup is Lectio Divina, a cross between an abbey dubbel and a saison; this one is bottled the same way and was the second Saint Somewhere beer to see bottles. The third and final regular offering is Pays du Soleil, a farmhouse ale made with hibiscus flowers and palmetto berries. This beer was the last addition to the regular lineup. Saint Somewhere also offers limited new drafts—mostly those named after members of the Sylvester family.

Sylvester teased pictures of a possible new facility for Saint Somewhere for the winter of 2015. While Sylvester has been talking about moving the brewery for a while, this is the most concrete he has been in his description.

Sea Dog Brewing
26200 North U.S. Highway 19, Clearwater, 33761
(727) 466-4916

After several attempts at carving a foothold into Florida, with the cute and loveable face of Sea Dog Brewing and Shipyard Brewing Company staking its claim in Florida (this time in Pinellas County), the Maine-based brewery has finally planted its flag. Shipyard Brewing wanted to join Florida's list of permanent residents and even almost bought the old Tampa Florida Brewery Inc. After several ventures that did not last, the Sea Dog brewpub has more than just a doghouse in Tampa Bay.

The Sea Dog Brewing Company of Clearwater opened its doors in February 2013 as a restaurant serving Shipyard's signature beers, although it had ambitions of becoming a brewpub. The bright and airy pub got by for a while using Shipyard and Sea Dog beers, but the community was looking for house beers with ties to the Maine brewery. Up to this point, the brewpub had been utilizing a smaller system to produce house beers and barrel-aged novelties for pub consumption. Head brewer Bobby Baker rolled up his sleeves and began brewing beers he thought best for his audience: Raspberry Stout, Drunken Honey Sour, Sand Dollar IPA and Reef Monster Blood Orange Wheat Ale.

Floridians had sounded a call to larger brewing, however, and Sea Dog responded with vim and vigor. The home office in Maine declared that the brewpub would sacrifice some patio space in exchange for a twenty-barrel brewing system. At the same time, Pinellas County loosened restrictions on craft brewers, allowing businesses zoned as "light manufacturing" to sell alcohol. The brewpub immediately got to work, converting patio space

into the future of Sea Dog and Shipyard operations in Florida—space that would eventually house brewing vessels and a canning line. The coup de grâce was the resurrection of a Shipyard classic: the same brewing system that brought Shipyard's freshest beers to the Orlando International Airport was reborn like a mighty phoenix from its cargo crate grave into brewing service.

Construction was completed, and the new Sea Dog made its debut in April 2014. What had begun as a noisy patio packed with the clatter of busy Clearwater traffic, construction and bustle suddenly became a patio, porch and neighborhood pub.

Silverking Brewing Company
325 East Lemon Street, Tarpon Springs, 34689
(727) 942-8697

Silverking Brewing Company is Tarpon Springs' second craft brewery and the first non–farmhouse ale brewery to grace the city with IPAs, porters and stouts. The brewery, as a company, was founded on June 19, 2012, during the fishermen's greatest time to hunt the silverking (another name for the Atlantic tarpon). Silverking opened in the former firehouse and Tarpon Springs jail. Despite the 2012 founding, Silverking began brewing in February 2015, and since the building it is in has historical significance, construction had to be diligent and deliberate, thus adding to the other work that had to be done in the wake of opening a craft brewery. In its life as the jail, the building was built in 1909, and it eventually transitioned into being a fire station. From time to time, the brewery staff welcomes old firefighters to the building to share stories. As for the beers, Silverking brewery is working out its lineup and developing its recipes. Stop by to get a firsthand account of all the progress.

Stilt House Brewing
625 U.S. 19 ALT, Palm Harbor, 34683
(727) 271-6958

Stilt House Brewing Company opened in 2015 with the intention of bringing great craft beer to the Palm Harbor area. Since Palm Harbor is still relatively untapped territory for craft breweries, Stilt House is a bit of

a novelty but is educating the consumers and working to make craft beer accessible to all. Best of all, with its proximity to the Pinellas Trail, many patrons can show up on bikes and then hop back on the trail for a ride down to Dunedin Brewery, 7venth Sun or Dunedin HOB Brewing.

Stilt House Brewing is still young in the Pinellas County craft beer scene. It poured its first beer, a Baltic porter, in its tasting room in late 2014 and has continued to evolve beers from there. In April 2015, Stilt House took over all of its own taps, with fifteen Stilt House beers on for the event.

Stilt House is still working through an initial lineup of beers, but so far, the highest praise has been for Berend Brown Ale, a nutty, malty English brown ale that has locals and tourists talking. Aside from that ale, Stilt House has tapped Back to Cali West Coast Pale Ale; Soul Candy, a 5 percent ABV milk stout; a St. Patrick's Day beer made with Lucky Charms cereal; and a Honey Jalapeño Cornbread Lager. Even though Stilt House is still working on tap lists and solidifying a regular lineup, the recipe book certainly has depth, especially to brew a lager when the brewery is so young.

Black Fox Meadery
1684 U.S. 19 ALT, Palm Harbor, 34683
(727) 218-0960

Black Fox Meadery is what happens when a former corporate accountant is looking for something to do that encompasses his favorite hobby of twenty-five years and time spent with his grandson. Bob Lasseter is the mead maker behind Black Fox Meadery of Palm Harbor, the only business in the state dedicated solely to the production of mead. (Many other businesses make mead, but they do so in conjunction with cider. Black Fox is alone in solely retailing mead.) Black Fox Meadery calls Palm Harbor in Pinellas County home, and Lasseter works out of an 1,100-square-foot space producing and selling this most ancient of beverages.

Unlike other businesses that make and ferment large amounts of mead at a time, Lasseter only makes about twelve gallons per week and sells it to walk-in customers or local bars. Along with his grandson, Noah Aleman, Lasseter makes small batches of mead and educates the public about what mead is and its storied past. In these small batches, Lasseter makes several varieties with which he is building his meadery: Bee Stinger, a mead made

with cherries and a bit of chipotle; Yo Mama, a mead based on apple pie with the taste of apples, cloves, cinnamon and nutmeg; and AceHole, a spice mead with vanilla, cinnamon, cloves, nutmeg and ginger root. Along with other specialty meads, Lasseter continues to expand Palm Harbor's appreciation of this time-honored beverage.

Hillsborough County

Tampa Bay Brewing Company
1600 East Eighth Avenue, Ybor City, 33605
(813) 247-1422

The Tampa Bay Brewing Company boasts one of the oldest brewpubs in the state of Florida, and it is only the second brewery in the state to can its beer. Nestled snugly underneath a movie theater in Centro Ybor, this pub has a problem keeping up with demand for its beer—a problem with solutions in sight. What started off with Brew Shack homebrew supplies has expanded to an almost iconic local brand.

The Doble family began raising the Tampa Bay Brewing Company in a small space on Eighth Street when they had a concept of bringing pub food and great beer together. The doors of the new facility opened, along with a patio around the walkway, and patrons paired local beer with pub food and bay breezes. The family is still intimately involved with the brewery: mother Vicki Doble runs the restaurant, son David Doble runs the brewery operations and son Mike Doble runs promotions and marketing for the pub. Other members of the family help, and recently, Tampa Bay brewer Tim Ogden moved in to help brew at the Ybor pub.

The beer that calls the shots at Tampa Bay Brewing Company is Old Elephant Foot IPA. This hop-forward West Coast IPA is a fan favorite and was the first TBBC beer to go into cans. While many locals and tourists love this hop monster, the latest addition to the can lineup, Reef Donkey American Pale Ale, brought home a bronze medal in the extremely competitive American Pale Ale Category at the Great American Beer Festival in 2014. This was the first time the brewery had entered a beer into the GABF national competition in ten years. The beer won out over 144 other entrants in the competition. Aside from the two canned hoppy beers, the brewery is planning to add True Blonde Ale to its sixteen-ounce can

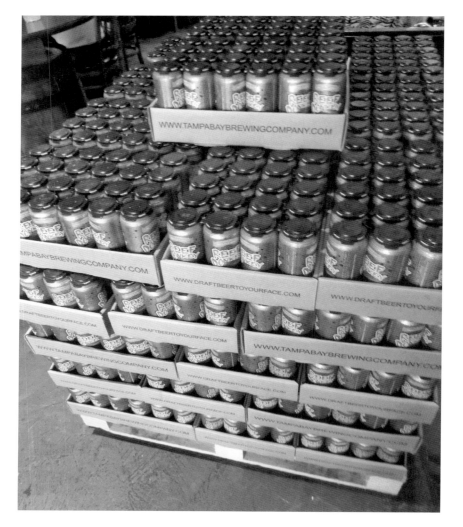

Cases of Tampa Bay Brewing Company's Reef Donkey Pale Ale ready for action. *Author's collection.*

lineup, as well as Full Moon Madness Subtropical Porter to sixteen-ounce and Mossekiller Barleywine to twelve-ounce.

TBBC anchors a solid lineup of core beers. Tampa Bay Brewing also has the light and mildly fruity True Blonde Ale, the hoppy One Night Stand Pale Ale, the light and wheaty Warthog Weizen, the roasty and chocolatey Jack the Quaffer Porter, the chocolate and coffee Iron Rat Imperial Stout and the sweet and toffee Moosekiller Barleywine.

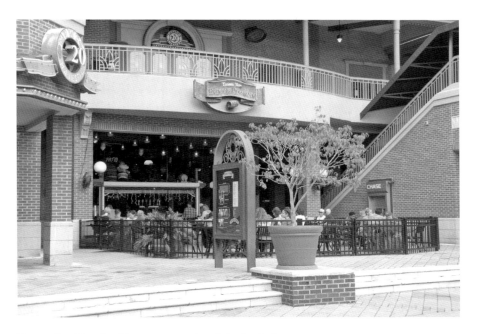

Tampa Bay Brewing Company exterior. *Author's collection.*

As one of Tampa's oldest breweries, Tampa Bay Brewing Company has a bit of popularity among locals and tourists as well. Owner Dave Doble used to have a show on the Weather Channel about his other job: flying airplanes for delivery to private owners. A flight on that show inspired the name of Midnight Crossing Black IPA. TBBC was also featured on *Diners, Drive-Ins and Dives* on the Food Network. Doble said he can always tell when an episode airs because of a sudden spike in attendance. The brewery's first run of cans make for collectors' items—as the pre-printed cans had not arrived, brewery staff labeled all cans by hand. Only cans from the first batch bear this distinction, as the rest of the cans have no visible silver showing.

Yuengling Brewery
11111 North Thirtieth Street, Tampa, 33612
(813) 972-8500

A big part of Tampa's current history, the Yuengling brewery is staggering in comparison to the other breweries of Tampa Bay. The brewery itself has a massive annual barrelage capacity. Nothing shows the size of the Yuengling

brewery off as much as a tour, which takes visitors through every stage of the beer-making process and is large and loud in comparison to any other tour. For instance, the twin brew kettles in the Yuengling brewery each hold five hundred barrels of liquid—that's more than 15,500 gallons in one brew session. Yuengling's beers are made on a massive scale compared to any other craft brewer in the state, and short of the Jacksonville Budweiser tour, it is likely that no other such tour exists in Florida.

Most of Yuengling's beers are available for sample in the brewery's tasting room. At the conclusion of the hour-and-fifteen-minute tour, Yuengling will give a sample to anyone over twenty-one. Yuengling's lineup is sustained by four lagers, two ales and one blend. Lord Chesterfield's Ale and Yuengling's roasty and coffee porter hold up the ale portion, while the amber-colored Traditional Lager, mildly grassy Premium Beer and the dual light-bodied Light Lager and Light Beer all bring it home for the lagers. The seven core Yuengling beers—as well as the bock, Oktoberfest and Summer Wheat (when each is available, respectively)—all pour from their Tampa home.

The Tampa Yuengling brewery is the largest producer of craft beer in the state of Florida. (Yuengling outpaced Samuel Adams and became the top producer of craft beer in the United States in 2014.) The plant, near the University of South Florida, is set slightly back from the road, but the unmistakable markings of a brewery have great drawing power in taking people out of their normal routine.

Cigar City Brewing
3924 West Spruce Street, Tampa, 33607
(813) 348-6363

Cigar City Brewing is the brainchild of owner Joey Redner, the man who never intended to own a brewery. Redner had worked odd jobs for a bit, owning a pub here and there, as well as working for FedEx and Dunedin Brewery at one point. Redner claimed that he never looked to be the beer guy; he was simply going to find the guy who wanted to start a brewery and work for him. But that guy did not come fast enough for Joey. Redner began the brewery with an investment from his father, who wrote a business plan, and started to fill the need that Tampa had for a large-scale production brewery. Redner hired Floridian Wayne Wambles, who had gained his brewing education brewing beer around the Southeast at Tallahassee's Buckhead Brewing and South Carolina's Foothills Brewing. The first employee after Wambles was a

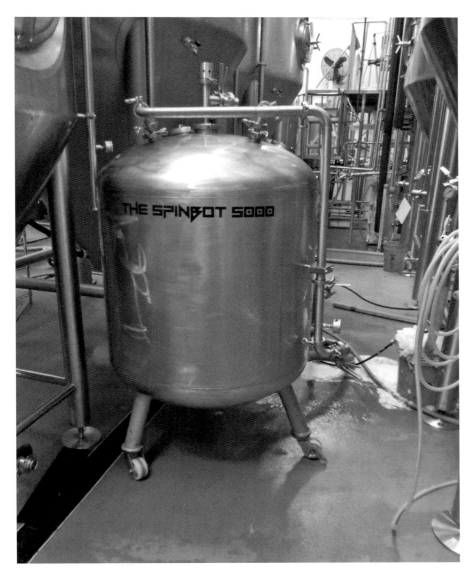

Cigar City Brewing's Spinbot 5000 turns a unique imperial stout into award-winning Hunahpu. *Author's collection.*

young assistant brewer named Doug Dozark, who would go on to run his own brewery in the future. Cigar City has been an incubator for brewing talent, with numerous other brewers beginning, refining or sustaining their craft there before moving on to their own breweries.

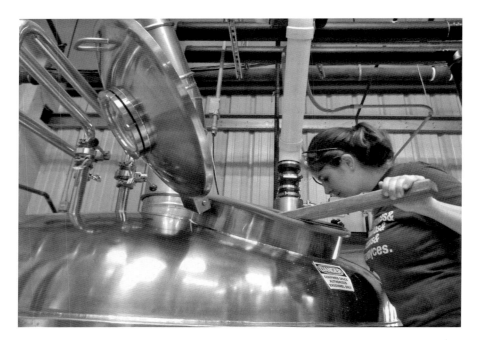

Cigar City brewer Megan O'Boyle supervising a brew. *Author's collection.*

Cigar City has a diverse lineup of core beers, but the beer that built the brewery is Jai Alai IPA. In 2015, one of every two Cigar City beers sold is a Jai Alai IPA. Its core lineup is all currently in cans: the light and citrusy Florida Cracker Witbier, an even lighter and clean Hotter than Helles Lager, the citrusy and bitter Tocobaga Red Ale and the light and citrusy sessionable Invasion Pale Ale, rounded out by the earthy and cocoa Maduro Brown Ale. White Oak Jai Alai (Jai Alai aged on white oak spirals) and Cubano Espresso Brown Ale (Maduro with Buddy Brew Coffee, vanilla and cacao) round out regular offerings as they alternate months of availability during the year. Cigar City's massive tasting room allows for lots of space to play around with the brewery's beers. Several dozen different Cigar City beers are available at any given time, with a few available for growlers to go.

Every year since 2010, Cigar City Brewing has hosted Hunahpu Day, the one-day beer release event where its thick, viscous Hunahpu's Imperial Stout is released. The first Hunahpu Day took place from 5:00 a.m. to 9:00 p.m. in the warehouse that is now called Brew House #1. That day went very smoothly, and there was a bit of extra Hunahpu left over the next day. The event has grown in popularity each year since then. Hunahpu Day 2013

saw a line that stretched for over a mile, with people lining up in the wee hours the night before. The brewery was forced to open the event early or Tampa Police would shut down the event before it began.

Hunahpu Day 2014 led many to believe that the event would be gone forever, as people lied and cheated to get in on an event that cost a $50 entry fee. The all-you-can-drink festival atmosphere combined with the massive number of people did not fare so well, and Cigar City did not have enough bottles for everyone. Cigar City closed the festival when people charged the line, and there was not enough beer to go around. The brewery then

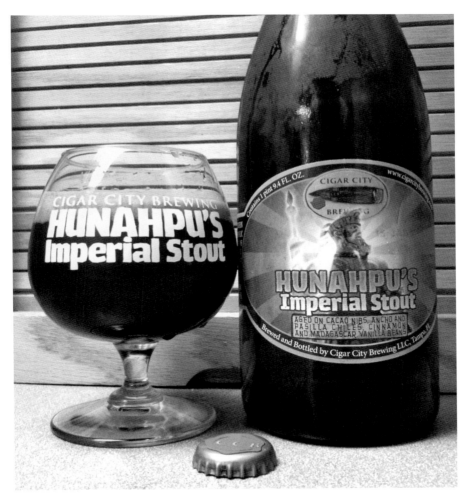

Cigar City Brewing's award-winning Hunahpu's Imperial Stout. *Author's collection.*

refunded everyone's money who paid for the event, gave away free beer in the tasting room the next day and swore never to do another event like Hunahpu Day. Then 2015 hit, and the last-ditch effort to revive Hunahpu Day came along—a $200 per ticket event that gave a plate of food, unlimited beers and four bottles of the $20/bottle beer to all who came out. This event went about with smiling faces, few complaints and relatively short lines. Hunahpu Day in its present form seems to be the way that Cigar City will proceed with the event into the future.

One more item of note with Cigar City Brewing is that it started the first Reserve Society that Tampa Bay had ever seen. This concept comes from the wine world, where members pay a fee to be part of the club. In exchange, the people get access to exclusive beers that no one else will be able to get. The club, named El Catador Club, began in 2013 and renews once each year.

Finally, check in with Cigar City for discounts. The brewery is friendly to the community and offers a discount if visitors ride a bike to the brewery, are teachers or active-duty military, are current or former presidents and/or happen to be members of the association of clowns. Or Snoop Dogg/Lion. He gets a discount as well.

Cigar City Brewpub
15491 North Dale Mabry Highway, Tampa, 33618
(813) 962-1274

The Cigar City Brewpub (CCB) is owner Joey Redner's expansion into the restaurant world with a Cigar City twist. The place is decorated with pictures of Cigar City employees (several of whom no longer work at Cigar City). The chandeliers over the bar are made from repurposed spirit barrels, and the light coverings are 750mL beer bottles. Cans of Cigar City beers line the walls, and the bar is lined with can tops as well.

The food is designed to be of a Tampa Cuban style. The Cuban sandwich, which many say originated in Tampa, is a staple of the menu. The menu is full of Tampa-inspired dishes, as well as those that involve the farm-to-table concept. Cigar City involves local farms and farmers as much as possible and includes this information wherever possible.

When he began as head brewer at the Cigar City Brewpub, Tim Ogden was charged with the mission of making the brewpub beers distinct from the brewery beers. Ogden was such a different brewer, with an immense palate to draw from,

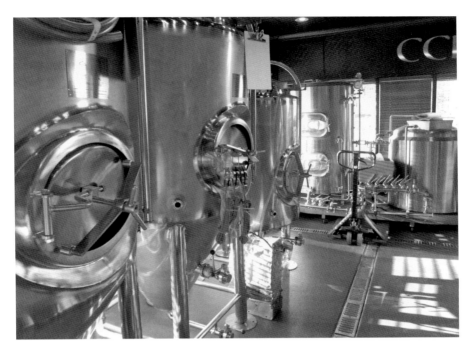

Cigar City Brewpub's small brewery. *Author's collection.*

that he could do just that. He drew up recipes for Paulina Pedrosa Brown Ale, a beer earthy with tones of molasses and tobacco; Fountain of Youth, a refreshing wheat beer with mild fruity notes; Northdale Pale Ale, a light and hoppy pale ale that went well in the hot Tampa summer; and other beers as he went along. Ogden would mature the brewpub beers and even bottle some of them. His Gourds of Thunder stout was a fall beer of a different color—one that put pumpkin and spice character behind a wall of roasty stout as opposed to making an uber-sweet pie beer. Ogden's Brewers Brunch Stout made a heavy chocolate, coffee and earthy stout that delivered everything it promised. Ogden was also able to collaborate with several musicians like Samiam and Alexander and the Grapes in his tenure. When Ogden moved on, CCB brewer Matt Tucker took over the brewing duties at the pub. Tucker brought in his own unique style of brewing, making Spider Wars IPA, a 4.3 percent alcohol session IPA, along with an array of styles through which the pub rotates regularly.

A trip to the Cigar City Brewpub has always yielded unique flavors between the food and the beer and can accommodate someone who wants "the usual" each time or one who wants to try something different with every meal.

Coppertail Brewing Company
2601 East Second Avenue, Ybor City, 33605
(813) 247-1500

Coppertail Brewing Company is a labor of love for owner and recovering corporate attorney Kent Bailey and head brewer Casey Hughes, who waited months to bring the brewery online and christen the former mayonnaise factory, olive cannery and warehouse into its new life as a craft brewery. The team underwent construction, delays and more construction in the hopes of finally pouring forth frothy and foamy ales in their spacious and Tampa-styled tasting room. From the outside, Coppertail's tasting room looks like a piece of Ybor City went wandering away, but on the inside, the cathedral ceilings and glass wall cue patrons into the sheer size and scale of this operation.

As Bailey notes on the company website, "Coppertail is dreaming of the impossible…like a couple of homebrewers putting everything on the line to start their own brewery. We believe in Coppertail."

In August 2014, that belief gave life to a brewery and kicked off with Bailey tapping a firkin of kumquat Free Dive IPA and saying a few words to a crowd of onlookers: "We're here. We have beer in the tanks…and I think we actually have a brewery going as of tomorrow."

That tomorrow is as bright as a bona fide Florida sunrise. Coppertail Brewing has quite a bit of beer capacity to speak of, bubbling to life with a fifty-barrel brewing system. Hughes will have his hands full keeping up with demand for Coppertail's beers, but that is not new for him. The native Floridian at the helm of Coppertail has brewed his way through the Florida Keys since the 1990s. Hughes then moved to New Jersey to brew at Flying Fish Brewing Company, win some awards and ultimately make his way back to the Sunshine State during its craft beer heyday.

Coppertail Brewing set its core beers before opening. One is Wheat Stroke, a hazy wheat beer that promises a nice bit of citrus with some light-bodied, wheaty fun. Free Dive IPA is an aptly named IPA, as too many of these 6 percent ABV beauties can certainly deliver a precipitous fall. This one does not disappoint, with the noticeable caramel backbone behind an assertive punch of tropical fruit, pine, grapefruit and kumquats. Unholy Tripel is so called for a reason: the alcohol goes virtually undetected. This devilishly big beer is a take on a classic Belgian-style tripel that hits the palate like a light-bodied lullaby. The nose is aggressively hoppy for the tripel style, which is usually a hop-mild style of beer. The flavor does not disappoint, as the hop

Right: Coppertail Brewing owner Kent Bailey with head brewer Casey Hughes tapping the first ever Coppertail beer. *Author's collection.*

Below: Coppertail head brewer Casey Hughes at the helm of the fifty-barrel brewhouse. *Author's collection.*

Left: Coppertail Brewing head brewer Casey Hughes. *Author's collection.*

Below: Aside from the core lineup, Coppertail Brewing occasionally releases beer in 750mL bottles. Seasonal Relief Baltic Porter (seen here) was its first release during Christmas 2014. *Author's collection.*

bitterness pushes through the flavor and into the finish. This beer should come with a caution sticker, as it has been known to get people into trouble.

Rounding out the lineup is Night Swim Porter, which pours as deep as the bay on a dark summer night—black with dark foamy ripples. The aroma starts with black coffee and earth, followed by sweet chocolate, dark chocolate and then some cacao nibs to round it off. As dark waves of chocolate lap against the palate, Night Swim delivers a roasty porter with depths of flavor from nose to finish.

Bailey said that Coppertail will introduce itself gradually to an increasing distribution footprint and add a few new beers to the special-release calendar, including a Stone Crab Stout (made with real stone crabs), a Berliner weisse and a French saison. Likened to the mythical Coppertailed beast itself, Coppertail Brewing is quickly becoming a reality in the Tampa and Florida craft beer scene.

Rock Brothers Brewing Company
1901 Fifteenth Street, Ybor City, 33605 (recently announced)

Rock Brothers Brewing Company is a Tampa brewery that moves to a different beat. Every beer that Rock Brothers makes is done in collaboration with a specific musician or band, and before the beer is labeled and sent, the beer must be tasted and approved by the band. The brewery is a company that uses "brewing partners" like Cigar City Brewing and/or Green Bench Brewing to write the recipes and fulfill the orders. The beer is then sent to the musicians' home markets in addition to the Tampa home of Rock Brothers.

Rock Brothers Brewing has been a bit of a vagabond company, mostly operating out of Cigar City Brewing, working with its brewers and relying on their expertise, but like a baby hop leaving the bine, Rock Brothers is branching out and will open a brewery, event space and venue all its own beginning in mid- to late 2015. The space is on Eighth Avenue in the Ybor City area of Tampa and is within brewing distance of Cigar City Cider and Mead.

Rock Brothers Brewing Company creates unique flavors in beer, with each flavor partially dreamed up by a musician with whom the brewery works. The first and most award-winning beer that Rock Brothers ever made was the light, hoppy High Road Pale Ale, made in conjunction with the Bradenton band Have Gun, Will Travel. The beer then went on to win a national championship at the United States Beer Tasting

Championship in 2013. After that, Rock Brothers brewed a coffee and toasted malt brown ale in collaboration with J.J. Grey. The beer, called Nare Sugar Brown Ale after the way Grey's grandfather took his coffee, is available in cans around the area and also has a version aged in bourbon barrels, released in March 2015. One of the biggest names at the time to sign with Rock Brothers was Hootie and the Blowfish, which gave input on Hootie's Homegrown Ale after the concert series that the band headlines every year. The beer itself is a light-bodied blonde ale with a twitch of lemongrass in the recipe. Coming next is a collaboration with the reggae/punk/funk fusion band 311, an amber ale, named for the band's biggest hit song of the same name.

Rock Brothers is working the collaboration angle that brewers employ with other brewers, all the while incorporating the ideas of musicians as artists in the same vein but a different medium. Once the beers are complete, Rock Brothers and the band work to promote the beer to the listening and drinking public, encouraging them to use all of their senses to experience the malty and musical ideas behind the beers.

Brew Bus Brewing
Brew Bus USA (Contract Brew)
(813) 990-7310

Brew Bus Brewing is the line of beers used by the Brew Bus USA Company to make any trip onboard one of its coaches a memorable experience. Brew Bus USA is the only company that allows patrons to drink their own unique beer during a bus ride and then have it available out on draft and in stores. Like a liquid calling card, the beer serves as a reminder of great times aboard the bus and a great group of flavors as well.

Brew Bus beers are contract-brewed through Cigar City Brewing. This means that Brew Bus has no tasting room of its own, but its beers are served and sold at Cigar City, which makes the beer.

Brew Bus has four core beers, with rotations of a seasonal and some limited-run beers for festivals. Rollin Dirty Irish Red Ale is a beer loaded with malt character that finishes mildly bitter. Are Wheat There Yet? is a hoppy wheat ale that has great flavors of lemon and bitter orange combined with the breadiness of a wheat beer. Last Stop IPA is a seemingly light-bodied IPA with a mild amount of alcohol in the trunk at 7.2 percent. Rounding out the regular lineup is Double Decker English Style Porter,

which tastes of chocolate malt, baker's chocolate and black coffee, with an aroma to match. Aside from these core beers, all available in four-packs, the bus rotates a seasonal called You're My Boy, Blue! Blueberry Wheat Ale. YMBB is available in the springtime, serendipitously around the time of the Florida Blueberry Festival. Finally, when beer festival season arises, look for Brew Bus Brewing to have a calling card of Nutella Porter, Lemon Last Stop or Blood Orange Last Stop. The company will take a treatment or two of the beer to showcase the beer to a new audience.

Tampa Bay Brew Bus Beers are distributed widely around the Sunshine State, and as the bus grows into new markets, the beer will have sped ahead and meet the bus at the next stop down the line.

Cigar City Cider and Mead
1812 North Fifteenth Street, Ybor City, 33605
(813) 242-6400

While Florida's craft breweries seem to be forever growing in number, counting the ranks of Florida's mead producers and cider makers would not even require the use of one's toes. While few are looking to join the ranks of Florida's honey wine and apple beverage makers, the crew of Cigar City Brewing has added another business to the family: Cigar City Cider and Mead.

Cigar City Cider and Mead has already been in production for a while—the cider was previously contracted out, but with the opening of the new facility and tasting room in Ybor City, the company has now taken direct control over production and the experimentation for which Cigar City is known. Every beverage from the fledgling company is made in Ybor City, with employees working every day to keep up with demand, one two-hundred-gallon batch at a time.

The head of creativity at the cidery and meadery is Jared Gilbert, a winemaker whose vision for Cigar City Cider and Mead is one of both balance and experimentation. The goal with this new company and new home is to "bring enlightenment to the market, especially when it comes to meads." Gilbert said that he believes balance is the key to both beverages and that the ideal is "not too sweet" and "not too dry." He wants to bring these drinks to the forefront of the industry. Cigar City owner Joey Redner has long valued meads not only as unique drinks but also as the only alcoholic beverages that can be produced solely with native Floridian ingredients. Gilbert agrees with this vision and wants to make meads with indigenous

Above: The owners of Cigar City Cider and Mead: Joey Redner, Justin Clark, Todd Strauss and winemaker Jared Gilbert. *Author's collection.*

Left: Cigar City Cider and Mead's vanilla mead, dubbed "The Vincente." *Author's collection.*

The interior of Cigar City Cider and Mead, detailing the different styles of mead. *Author's collection.*

avocado honey and mangrove honey, as well as expand into a barrel program for barrel aging meads and ciders.

As of its opening, the new Cigar City Cider and Mead tasting room and production house has showcased some of Gilbert's creations and pop culture knowledge with a spectrum of ciders like "There's Always Money in the Banana Stand" banana cider, a strawberry banana cider, a dry-hopped mango cider and a black currant cider along with a vanilla mead, a blackberry sourwood mead and a strawberry shortcake demi-sec.

Cigar City Cider and Mead operates in a building that has already made Tampa history. Number 1812 North Fifteenth Street in Ybor City first housed the Tampa Bay Brewing Company in its youth. Since this cider and mead facility actually exists within the boundaries of Ybor City, and in keeping with the Cigar City sense of humor, rumor has it that Redner and crew will erect a sister sign to the one that stands in front of the brewery reading, "In Ybor Since 2014." (The sign in front of the brewery is a testament to the confusion many folks exhibit when they mistakenly believe that the Cigar City Brewing is housed in Ybor City; it reads, "Not in Ybor Since 2009.")

TAMPA BAY BEER

Cigar City Airport Pub
4100 George J. Bean Parkway, Tampa, 33607
(813) 870-8700

The Cigar City Airport Pub is a revolutionary idea that brings the concept of a brewer making fresh beer into an area that has a constant flow of people going through it. The downside is that space is at a premium. The brewery has so many irons in the fire that the airport brewery keeps a steady stock of Cigar City, but it may not often have a stock of airport brewery–only beer. This is not to say that Cigar City does not take care of this pub; in fact, it has been known to get rare and hard-to-find kegs of beer. The airport pub reportedly had on draft a keg of Hunahpu during Hunahpu Day in 2015.

The tiny pub looks like a piece of Tampa's Ybor City or a West Tampa cigar factory has been magicked into the middle of the airport. From its brick façade to its signs rising over travelers, this pub is the next best thing to visiting the brewery, especially during a layover or short time in the airport.

The airport pub began with at least one beer all its own: Tony Jannus Pale Ale, named for the pioneer Bay Area pilot who flew the first commercial flights ever, between Tampa and St. Petersburg. As part of its calling to bring Tampa's history into its beers, Cigar City Brewing named its fresh pale ale after Jannus and put it on draft only at the Spruce Street home of Cigar City and at the Cigar City Airport Pub. Aside from Tony Jannus, the pub offers Cigar City favorites, most of the core lineup and a rotation of seasonal beers to any traveler with the time to stop over.

ESB Brewing
333 North Falkenburg Road, Tampa, 33619
(813) 990-0700

ESB Brewing is the tripartite of three beer lovers, uniting to help share their favorite beers with the Tampa Bay area. The title, ESB Brewing, comes not from the style of beer (English special bitter) but from the first letters of the names of the people involved in the venture. Tied with Booth's Brewing and Bar Supply down the plaza, this brewery is sharing plenty of new flavors with the people of the Brandon area.

ESB Brewing works to keep the small tasting room stocked with its house beers and also tries to send a few kegs out to distribution each week. The small, pirate-themed brewery sails on and tries to keep up with demand.

Since ESB got a brewery license as of December 2013, the tasting room drinks dry much of the brewery's best efforts. That being said, many thirsty people come to ESB expecting the brewery's stalwart sailor, Pieces of Eight Double IPA, to be on tap. This uber-bitter beer is hopped with eight different varieties of hops, as the name alludes. Aside from Pieces of Eight's hop assault, ESB presents flavors as diverse as the colors of the rainbow. Anything from a boozy barrel-aged stout to a Strawberry Ice Cream Ale or Pecan Nut Brown Ale could be on during any of the days that ESB is open (Wednesday through Saturday).

ESB's website promises that a brewery expansion is coming down the line soon enough. After the first year of operation, ESB is looking to bottle and/or can its beers and expand offerings just as soon as expansion is in the proverbial cards. The most consistent supply of ESB beer, as with every other brewery in Tampa Bay, is direct from the source—in this case the Brandon-area taproom.

Citrus Park Brewery (at House of Beer)
8552 Gunn Highway, Odessa, 33556
(813) 920-8889

Citrus Park Brewery, along with Citrus Park House of Beer, is another member of the brewery-in-an-established-bar movement, and with an award-winning chef at the helm, the brewery is not slowing down any time soon.

When the Citrus Park House of Beer wanted someone to run its brewery and another someone to run its barbecue kitchen program, the owners found a jack-of-both-trades in current head brewer Jeremy Denny. Denny is an award-winning barbecue chef who also homebrews and loves the challenge of building flavor profiles in both food and beer. Denny has been doing this at Citrus Park Brewery since November 2014, and the brewery's reputation has grown ever since. Denny loves the challenge of keeping the taps stocked with CPB beer and does his best to keep eight to ten house beers on at all times. He loves seeing a customer give his beer a chance and then order a whole pint of it, knowing that something of the brewer's art registered with that person.

Denny produces several core beers, many rotating taps and a few experimental beers, trying to tempt the tastes of locals in Citrus Park and beyond. In order to try CPB beers, however, the taster must come to the brewery, as there is no room to expand and not enough space to make enough beer to meet demand outside the bar. It was a great challenge

for Denny to brew and package twenty kegs' worth of beer for a CPB tap takeover during Tampa Bay Beer Week; after the event, it took him a while to get the number of house beers back up. This comes in large part because Denny is brewing on a two-barrel brewing system, allowing his beers to ferment in conical fermenters and then finishing fermentation in the kegs in which they will be served.

Like a chef building a dish, Denny said that he approaches every beer the same way. He begins with the core flavors and works his way outward, adding nuances and complementary pieces to the overall taste profile. As of April 2015, Denny has twenty-four rotating styles of beer, one beer with an annual launch and several beers that make heavy rotation and could be called core beers. Growing the core lineup is the Fruit Cocktail Kölsch, a kölsch-style ale aged on pineapples, cherries and papayas. Next is the Agrarian Tripel, a Belgian-style ale that pours hazy and has a yeasty, somewhat fruity and citrusy character. The final core is Hop Love IPA, a bitter IPA that will premiere for the first time in mid-April 2015; Denny expects to have room for this one regularly.

After the core lineup, CPB works through beers systematically and makes room for beers anywhere, from the usual suspects hoppy IPAs and roasty stouts to the unusual and out there ones like Caramel Hefeweizen, Red Eye Red Ale and Milk N Cereal. For Caramel Hefeweizen, Denny makes a hefeweizen but uses caramel malts, so instead of a traditional hazy-yellow hefeweizen, what pours is a grainy and caramel-tasting brown-colored ale. For Red Eye Red Ale, Denny begins brewing the cold-pressed espresso for this coffee-infused ale thirty days in advance. He incorporates green coffee beans, so instead of dark and roasty coffee, the beer expresses more notes of green and fruity coffee beans. Finally, with Milk N Cereal, Denny wanted to go for something completely different. In this beer, he wanted to simulate all the flavors of a bowl of cereal, just the way they appear in beer rather than a sugar-frosted breakfast. To this end, Denny took corn, rice, oats, barley and wheat and brewed a beer that incorporated milk sugar and added some El Dorado hops. What resulted was a beer that did what Denny wanted but tells the story of how different these flavors can be when melded in a beer glass.

Look for this small brewery to continue to grow slowly. With 2,400 square feet in the bar, space is at a premium, especially since Denny runs the barbecue program for the bar with his competition recipes. Few breweries in Tampa Bay can boast that the food and beer are consistently made by the same person. Many brewers cook and some cooks brew, but few do both the same way as Citrus Park Brewery.

Two Henrys Brewing Company
5210 West Thonotosassa Road, Plant City, 33565
(813) 752-3892

Florida lore notes that the history and progress of building up the state was the work of two men. The development of Florida was the "Tale of Two Henrys," and it is these two men that Two Henrys Brewing Company honors. Henry Flagler built the railroads on the east coast of Florida, and Henry Plant did the same on the west coast, hence why the University of Tampa was the former Plant Hotel and Flagler College the former Flagler Hotel. Those same railroads connected Plant City to Tampa and the brewery to Florida history.

Two Henrys Brewing Company is what happens when a winemaker wants beer. The brewery and tasting room is on the site of the Keel and Curely Winery, which specializes in fruit wines. Owner Clay Keel opened the brewery in October 2013, and it has grown ever since.

The most widely available Two Henrys beer is its 7 Mile Bridge English IPA, with the light and crisp Gilded Age Lager also available in cans. As of April 2015, cans of Biltmore Blueberry Vanilla Wheat Ale are also available at Two Henrys. Finally, every so often the brewery releases a beer in 750mL wine bottles for locals and tourists to buy through the tasting room. In 2015, the brewery released Hop Tycoon, an 8.5 percent ABV double IPA.

Two Henrys has also forayed into the world of cider production, with a cider or two available to tasting room patrons and the curious alike. Two Henrys has a plain cider, a blueberry and a strawberry cider for those interested. Two Henrys is one of only a handful of Tampa breweries now making hard cider.

Southern Brewing and Winemaking
4500 North Nebraska Avenue, Tampa, 33603
(813) 238-7800

Southern Brewing and Winemaking proves every day that whoever came up with the old adage "Those who can, do and those who can't, teach" was clueless about educators. After years of teaching Tampa-area homebrewers about beer making, the homebrew shop began using one of the larger brewing systems that it sold to make beer to sell on site, either inside or in its recently expanded beer garden.

Southern Brewing and Winemaking, both brewery and homebrew shop, is run by husband-and-wife team Brian and Kelly Fenstermacher. Brian has worked in the grain supply business and worked with Ybor City Brewing Company, Atlanta Brewing and other operations before deciding to go into business for himself and help homebrewers hone their craft.

Southern Brewing loves the brewing that it does and is content with the setup it currently has at the Seminole Heights–area brewery. The beer is always made on site and made to be consumed on site as well— Southern has no distribution ambitions at the present time. It brews in small batches, and experimental beers may never see the light of day once they're gone. That really just depends on popularity and the brewer who crafted the beer. Southern also does not continually post about special beer releases, so on any given night at the brewery there might be a barrel-aged sour, a delicate mead and a high-gravity IPA right next to a fresh pale ale and a Belgian wit. The beauty of Southern Brewing is that it turns beers over, and there is no telling what could be on draft next.

Look to Southern Brewing for a varied array of beers, ciders and meads from around the world of inspiration. Because Southern is

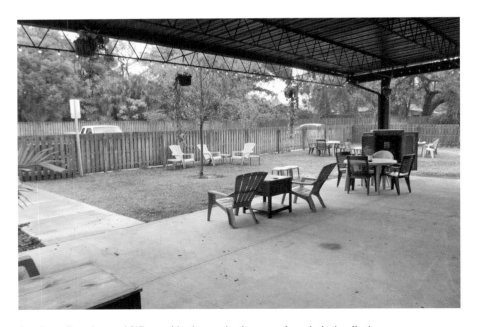

Southern Brewing and Winemaking's exterior beer garden. *Author's collection.*

also a homebrew shop, it has more than 110 grains and more than 50 types of hops, as well as many of the world's leading yeast strains from professional yeast labs. There is wood for aging, honey for adding and an assorted array of ingredients to add to any given brew. Southern tries to stay with a few select favorite beers on tap at all times, but from there, the sky is the limit, especially since the brewery does not usually prep the community for a beer release. Look for regular appearances from beers like the lemon and coriander Kelly's Belgian Wit, the roasty and chocolatey Moonraker Stout and/or several hoppy beers with any number or combination of hops. These beers are served with a dose of brewing advice, if needed, or a limited selection of bottles in the cooler. Southern is a jewel in the crown of Seminole Heights, since the neighborhood has three very different breweries that call it home (and a fourth in the works).

Angry Chair
6401 North Florida Avenue, Tampa, 33604
(813) 238-1122

Angry Chair opened its doors in 2014 after much waiting and much time spent finding a facility, constructing a brewery and then dealing with the red tape and minutiae that come with the last two items. Co-owners Ryan Dowdle and Shane Mozur have built a great addition to the Seminole Heights area of Tampa; Ben Romano's beers make them all the more welcome.

Angry Chair's brewer, Ben Romano, has quite a reputation. He was the pilot brewer at Cigar City Brewing and made some of the most memorable small-batch beers that Cigar City ever poured. Ben was never famous for his work at Cigar City, as he was a man behind the scenes. Many of his session pale ales and SMaSH beers would seem to evaporate from the tap list hours after being tapped. When Romano began brewing with Angry Chair, the brewery started light—a gose, a session IPA and a hoppy red ale were the prime offerings. Once Angry Chair got some dirt under its nails, Romano brought on a citrusy IPA, a delectable orange and lemon white IPA, a dessert-in-a-glass German Chocolate Cupcake Stout and an unforgettable coffee chocolate stout simply called The Awakening. As Angry Chair continues to solidify its core offerings and seasonal beers, look for more unique flavorful beers and memorable events.

Angry Chair Brewing exterior. *Author's collection.*

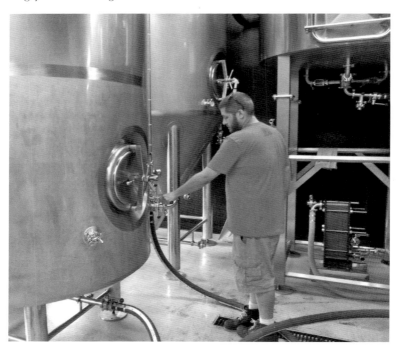

Angry Chair Brewing head brewer Ben Romano. *Author's collection.*

Since opening in December 2014, Angry Chair has already hosted an event honoring wrestling legend Randy Savage, brewed a beer in honor of '80s video game boxing legend Soda Popinski, barrel aged that beer in bourbon and rye whiskey barrels and poured several sour ales and tart Berliner weisses. Angry Chair is in the fast lane toward Tampa's heart.

The most important item to remember for any visit to Angry Chair is to abide by its motto: "Don't park on Fern." The neighbors do not appreciate the added traffic, and the brewery has been adamant about making this known. It even has T-shirts with this motto.

Angry Chair Brewing's first bottle release: 3 Little Birds Florida Weisse. *Author's collection.*

Florida Avenue Ales
4101 North Florida Avenue, Tampa, 33603
(813) 374-2101

Cold Storage Craft Brewery came into Tampa quietly and worked to build a name for itself. The brewery runs a tasting room off the front of its facility, the former Kash and Karry supermarket on its namesake street in Seminole Heights. Before the tasting room, the brewery was open to the public one day each month for tours and tastings. The brewery christened itself as Cold Storage Craft Brewery, after the Cold Storage Café in downtown Tampa, but quickly saw that the public had an affinity for its "Florida Avenue Ales." So, the brewery's beers all bear the Florida Avenue Ales logo along with the pirate ship synonymous with the city of Tampa.

Cold Storage Craft Brewery began in July 2010 when a veteran homebrewer and his business partners found an empty grocery store. After some renovation, the building was ready to house beer-making equipment,

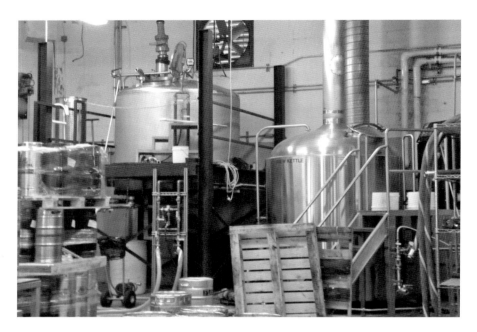

The old Anheuser-Busch brewing equipment at Florida Avenue Ales. *Author's collection.*

and the partners added a business room where distributors and business associates could meet to sample the brewery's beers. In craft beer, finding brewing equipment is usually a difficult process. Since so many breweries are looking, used equipment can be more expensive and tougher to find than new equipment, except that new equipment usually takes six to eighteen months to build from scratch. Florida Avenue Ales got lucky. The brewing equipment from the Anheuser-Busch Tampa brewery had been sitting vacant at the old Busch Gardens. When the executives in St. Louis had sold the company to AB InBev of Belgium, they divested themselves of the Busch Gardens park, and the brewing equipment had to go. Cold Storage was then able to acquire some of the oldest and most storied brewing equipment of the time (the ones in the Yuengling building being built around the same time).

The brewery then continued on course until some staffing changes brought brewer Aaron Barth to Florida Avenue. Barth mastered the brewing of the core lineup of Florida Avenue ales and is now working to put a focus on innovating and drawing the attention of beer enthusiasts to Florida Avenue. Efforts have been paying off so far, as Barth's Maple Milk Stout won a silver medal at the 2015 Best Florida Beer Competition. The vast majority of the beer that comes from Florida Avenue arrives in six-packs and kegs of the

core three beers: Florida Avenue Ale, Florida Avenue Blueberry Ale and Florida Avenue India Pale Ale. In 2012, the brewery began to cycle into seasonal beers with an amber ale dubbed Copperhead Ale and a brown ale dubbed Betchy Brown. Florida Avenue Ales are available on draft from St. Petersburg to Tampa and Orlando and south to Key West, and in 2013, the brewery signed on to begin shipping beer to Gainesville and St. Augustine, working to complete statewide distribution.

Three Palms Brewing
1509 Hobbs Street, Tampa, 33619
(888) 813-4859

Three Palms Brewing Company is one of Tampa's smaller breweries, nestled in the Brandon area. Established in 2012, Three Palms was created by a former network engineer/contractor. It is the original craft brewery for the Brandon area of Tampa.

Randy Reaver founded Three Palms Brewing when he was looking for work. Reaver homebrewed for five years before deciding to open a brewery of his own. In the interim, he could see the success of breweries close to home and throughout the United States. He reasoned, "If beer could be made in such diverse areas all over the globe, why not in Brandon?"

Three Palms is currently housed in an industrial park in Brandon and was born on the Fourth of July in 2012—at least that's when the first batch of Three Palms beer was made after all the planning and permitting was finished for the brewery. Three Palms has continued to grow, and because of local patrons and Reaver's efforts, the brewery built a tasting room addition to the brewery where locals can come and enjoy a beer or two as well as a tour of how and where Three Palms Beer is made.

Currently, Reaver is working from an expanded 145-gallon brewing system to fill his kegs as quickly as he and his staff can. This expanded system is a welcome change from their early 55-gallon system. As for the regularly scheduled beer program, it is headed up by Zip Zag Berliner Weisse, Going the Distance Session IPA, Sir Albert's Reserve Double Stout and Hot Schtuff Ghost Pepper Cinnamon Stout. Look for an increasing array of beers from Reaver and Three Palms. Randy said that he is inspired by life, its events and his fellow brewers.

TAMPA BAY BEER

Wild Rover Brewery
8740 North Mobley Road, Odessa, 33556
(813) 475-5995

The Wild Rover Brewery, Keystone's craft brewery, was born from a desire to bring the heart and feel of a cozy English pub to the border of Pasco and Pinellas Counties. Father-and-son team Derek and Ricky Wells founded and built the Wild Rover as a local brewpub where friends could gather to socialize and have a beer brewed in their community. The heart of an English pub is a community gathering place, and that is what the Wells have created in this space. There was not enough space for a kitchen, so the brewery added an homage to their English roots with a double-decker bus as a partial kitchen space to satisfy the appetites of hungry patrons while they are still in the confines of the brewery.

The inside of the pub has lots of wood and feels loved like a generational English public house. It has all the feel of a place where a spouse would walk out the door at night, yelling to his or her mate, "I'm going down the pub for a pint." While this may seem stereotypical, the folks at Wild Rover are only missing small touches to indicate that the pub is not from Her Majesty's isle.

Wild Rover Brewery exterior (with bus). *Author's collection.*

The Wild Rover brews on a four-barrel brewing system and makes its beer with love in a setting named for a traditional Irish song honoring a pub of the same name. While the name implies a heavy reliance on the English tradition, the Wild Rover has no fear of filling taps with styles of beer from areas outside Great Britain, as long as the house beers are quality. The mainstay of Wild Rover is an English mild called the Mild Rover. This beer is a beloved style in Great Britain, combining a flavorful ale with a low alcohol content, allowing a thirsty patron to drink a few before the alcohol begins to have an effect. Aside from Mild Rover, there is another in a traditionally English style called Let It ESB—an English beer with "English" in the name and a Beatles reference, too. Completing the Wild Rover tap list is anything from a Russian imperial stout to a rye porter (in this case a collaboration with Cigar City Brewing) or any number of more than a dozen styles in between. While the Rover leans toward English styles, brewery staff do not pigeonhole themselves to one set of styles. With an open mind and a wandering palate, Wild Rover finds a diverse array of styles, all brewed with the idea of community in mind.

Six Ten Brewing Company
7052 Benjamin Road, Tampa, 33634
(813) 886-0610

Six Ten Brewing Company is named after that dream job—the one that folks dream of outside the normal nine-to-five grind. That is what the brewery is for brewer Chris Johnson and his wife, Leslie, both of whom left their "normal" daily jobs to pursue the dream and the passion of running a commercial brewery. Six Ten is a production brewery in the Town 'n' Country area of Tampa that has been open since Valentine's Day 2014. The Johnsons still enjoy getting out of bed every morning to make beer and help patrons find beers that cause an epiphany.

Both husband and wife use a combination of their education and their passion to move Six Ten forward. With Chris and Leslie both being from the tech sector, finding out what is on draft at Six Ten is as easy as downloading an app for the iPhone or Android—just check the iTunes store or Google Play. Chris is also a member of the Tampa Bay BEERS homebrew club, and he does what he can to continually support the club. He is aware that the next award-winning craft brewers are brewing on home systems and carboys as this is being read.

As for the beers, Six Ten staff brew the beers that they truly enjoy sharing. The brewery bestseller is Magpie Rye, a rye pale ale dry-hopped

with Amarillo hops. Six Ten beers have a wide array of flavors—everything from a light and tart Berliner weisse called CBGB, after the legendary New York rock club, to a coriander and orange peel saison to a deep and roasty porter to a bold, brash double IPA. Six Ten's flavors run the gamut and have something for every taste and every experience level of beer drinker. Six Ten works very hard not to intimidate beer drinkers—the staff know that not everyone is Michael Jackson (the beer writer, not the singer—may they both rest in peace), and they want to present a stress-free environment to try beers, love beers or move on to another beer. Just like how Chris and Leslie found their favorite beers, so, too, can anyone who walks in. Or, if the decision has already been made, then there is a place to order a growler.

Ulele
1810 North Highland Avenue, Tampa, 33602
(813) 999-4952

Ulele was built as a testament to many Tampa icons. First, Ulele was built to showcase Florida food and Florida beer, working diligently and playing harmoniously together. Next, the restaurant is a testament to the Gonzmart family, who preside over the Columbia Restaurant Group, whose flagship restaurant is the oldest in Florida. To hear Richard Gonzmart speak about his passion for building a brewery and his grandfather's affiliation with Tampa's first craft brewery brings back vivid pictures of the Tampa of yesteryear. Finally, the restaurant and brewery are at the head of Ulele Springs, a pristine spring that is named for a Tocobaga princess who spared the life of a Spanish boy who was set to be executed by her father. The tale comes from Tampa lore during the time of Spanish exploration, in the 1500s.

Today, Ulele is a restaurant and brewery that carries on the Gonzmart family legacy with incredible food and a versatile palette of beer to pair with that food.

The Columbia Restaurant Group and the Gonzmart family did not take the addition of a brewery lightly. Richard Gonzmart has family ties to the old Florida Brewing Company of Ybor City. After all, the Columbia Café (which predates the restaurant) was a tasting room for Ybor City's original brewery dating back to the 1890s. Gonzmart knew that the beers Ulele produced would have to pair well with the food and invite beer enthusiasts both emerging and seasoned to give them a try. Gonzmart hired brewmaster

Ulele Brewpub exterior. *Author's collection.*

Ulele brewmaster Tim Shackton receives a medal in the 2015 Best Florida Beer Competition. *Author's collection.*

Ulele Brewpub brewer Tim Shackton gives a talk about his brewhouse at Ulele. *Author's collection.*

Tim Shackton, an alumnus of the Hops chain and a seasoned Florida brewer, to accomplish this heady mission.

Once he was on board, Shackton hit the ground brewing with his shiny new JV Northwestern fifteen-barrel brewhouse. Currently, Shackton stocks Ulele's bar with three beers that will likely become part of the core lineup. Managing partner Keith Sedita said that Ulele will carry six taps of beer, likely five standards and one rotating tap. Once Shackton gets his legs under him and the pub is in full swing, the only limit to the beers he can brew is the limit of his own imagination.

As Shackton develops Ulele's beers based on the tastes of patrons, he has made big plans for the brewhouse at Ulele. Those plans? Shackton is not extremely forthcoming, but he has hinted at some of the tools in his proverbial garage: "a Patron tequila barrel and a Knob Creek Distilling barrel," among other surprises. Shackton has not filled these barrels yet but teased the imagination of what beer could possibly take up residence inside these oaken havens. Once in barrels, Shackton would lay these barrels down inside the cooler and let nature and the barrels make their magic. The only thing that Shackton's plans do not include is serving beer by the pitcher. "I want my beer to be cold when people

enjoy it," Tim said—that means not serving the beer in a vessel that will allow it to warm up past prime temperatures.

Once out of the brewhouse, Shackton's beers have a Florida-centric menu of partner foods with which to dance. Working closely with chef Eric Lackey, Shackton has designed his beers for Ulele's menu, and that menu is an eclectic one. Gonzmart drew inspiration from some of the boldest flavors in Florida's well. Ulele's copious oyster choices, Fresh from Florida Strickland Ranch steaks and a chef-inspired ice cream menu will allow Shackton a plethora of pairing choices.

Ulele is about more than the typical "farm to table" concept; it is about sustainability. Sustainability is using 70 percent less water to wash dishes. The building is refurbished from 1903. Sustainability means sending spent brewery grains from Ulele's brewery to Strickland Ranch to feed the cows— what is taken from the restaurant can be brought back to the menu.

Ulele's core beers include Ulele Light, a light straw-yellow lager with a white head. It's a light-bodied, versatile food-pairing beer with some malty and grainy characteristics, as well as some yeasty character in the background. This "light" will go well with Ulele's shellfish and salad courses. Next is Water Works Pale, a pale lager that starts off with some malt character, goes into some tropical fruit and citrus and then works its way back around to a balanced yeastiness, finishing clean with a hint of citrus. This larger-than-light pale will go well with Ulele's calamari, grouper and crab mac 'n' cheese. Next in line is Rusty's Red, which pours its characteristic red color with an off-white head. The beer starts off with some caramel and toast in the aroma followed by the same and some mild bitterness and citrus character in the flavor. This one looks to go great with anything on the sides menu, as well as the meatloaf. Rounding out the lineup is Magbee's Honey Lager. This one has a twist of honey to add a hint of sweetness. Light in body, this beer will pair well with sunsets, dessert or snapper.

St. Petersburg

Peg's Cantina/Orange Belt Brewing
3038 Beach Boulevard, Gulfport, 33707
(727) 328-2720

Peg's Cantina was one of the St. Petersburg–area craft beer staples in a time when craft beer was just beginning to flow from Tampa Bay taps. Peg's hosted

the first Berliner Bash, Peg's brewer Doug Dozark's springboard when he was running through ideas. Peg's was a great place to have a meal, sit around a great patio and people-watch while enjoying a pint. In the present day, brewing operations have mostly moved to Cycle Brewing in St. Petersburg, but this is about to change. Dozark announced that he wants to begin a side project at Peg's for Cycle assistant brewer Eric Trinosky. That project will be called Orange Belt Brewing.

Peg's Cantina is owned by Peg and Tony, Doug's parents. The two were tired of life in the world of academia, so they left and opened a restaurant. Peg's Cantina is a small, mostly open-air restaurant in the heart of Pinellas County's Gulfport. Beach Boulevard is only moments from the beach, and the breeze is always blowing through Peg's. The core lineup at Peg's is much the same as the core lineup at Cycle, but there will always be several possible additions and guest taps at the place.

One of the exciting announcements of the addition of Orange Belt Brewing to Peg's is the rebirth of the Peg's Berliner weisses. When Doug Dozark started experimenting with Berliner weisses, he brewed many of them at Peg's and would put them on randomly, many of them during Berliner Bash at the Cantina, the once-yearly celebration of tart wheat beers. Due to issues with these beers, Dozark has sworn them off, but Eric Trinosky has been instrumental in bringing them back to Peg's and Cycle. Hopefully by the time Orange Belt is up and running, these beers will be back for good.

Cycle Brewing Company
534 Central Avenue, St. Petersburg, 33701
(727) 328-2720

Cycle Brewing is former Peg's head brewer Doug Dozark striking out of Peg's Cantina to build his own brewery in downtown St. Petersburg. Doug began building out of a former drugstore at 534 Central Avenue in St. Petersburg, and soon enough he saw opening day as a possibility except for one thing: St. Petersburg was not able to zone breweries at the time. Thankfully for Dozark, Green Bench owner Steve Duffy was in the process of helping to rewrite the zoning in the city, and Dozark actually opened before Green Bench Brewing, taking advantage of the road that a neighboring brewery had paved. While Green Bench welcomed Doug to the downtown concourse, thanks to its work Doug was able to claim the title as St. Petersburg's first craft brewery.

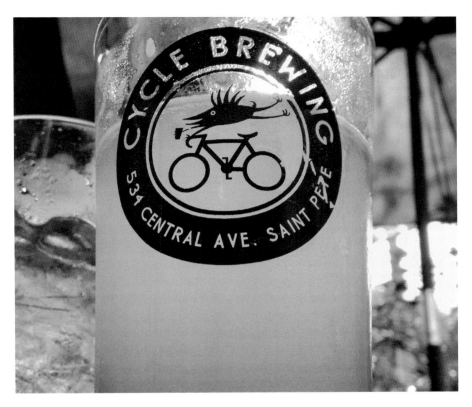

A Cycle beer enjoyed outside at Peg's Cantina. *Author's collection.*

In this small storefront, on a seven-barrel brewing system, Doug raises expectations every day. Cycle always has at least one session IPA on tap at all times. This beer is usually Fixie, a much-beloved IPA around town. Cycle also has on tap the coffee-forward Cream and Sugar Please?, the earthy and mildly chocolatey Bottom of the Ninth Brown Ale, the light lager called Ducky's Pils (a beer brewed for the lounge co-owned by Tampa Bay Ray Evan Longoria) and a few others. The brewery has occasional surprises like Derailleur Double IPA, Chain Slap Imperial Stout or even a barrel-aged imperial stout on draft at any given time. In 2015, Cycle signed on to distribute a limited number of its beers around the area; before that time, Cycle beers were mostly confined to Peg's and Cycle itself.

During Tampa Bay Beer Week, Cycle has begun releasing a different bottled barrel-aged imperial stout each day, finishing the week with

Barrel Aged Day, showcasing the art of barrel aging beers. Check social media early, as these events and bottles do sell out, and folks do line up for these.

Green Bench Brewing Company
1133 Baum Avenue North, St. Petersburg, 33705
(727) 214-4863

Green Bench Brewing Company has been working to promote the St. Petersburg craft beer scene since before it opened. Brewer Khris Johnson has made beer with Southern Brewing and Winemaking as well as Cigar City and is moving to making unique styles of beer at Green Bench. Co-owner Steven Duffy is the reason why craft beer exists in downtown St. Petersburg. Before the brewery was even ready to open, Green Bench was working hard to make itself known to the Bay Area through beer festivals and collaborative beers.

Green Bench Brewing makes hop-forward beers, earthy stouts, farmhouse ales and a unique line of Belgian-inspired ales that showcase the creative

The exterior mural of Green Bench Brewing Company celebrates the city's history. *Author's collection.*

Above: Brewing system at Green Bench Brewing Company. *Author's collection.*

Right: Green Bench Brewing Company likes to release special bottles in a series—this one showcases Russian Mail Order Bride, an imperial stout with matching barrel-aged variants. *Author's collection.*

teamwork of the brewer and the yeast. These Belgian-inspired ales are 100 percent oak-fermented in custom-built oak foeders. Those foeders allow the beer a place to rest and take on the character of the wood combined with any character that the yeast imparts on the beer. Johnson uses brettanomyces and lactobacillus, among other yeasts, each of which imparts different flavors on the beers.

When Green Bench began brewing, the core lineup of regular beers was up in the air, but now that the brewery has been in operation for more than a year, it has solidified somewhat. Always on draft at Green Bench are its Skyway Wheat, a hop-forward dry citrus and piney wheat beer; Green Bench IPA, the Green Bench flagship IPA that has notes of soft citrus, pine and some light tropical fruits; Demens Black IPA, a roasty and earthy black IPA that is aggressively hopped; and a few occasional friends and leftover bottles that also become available at Green Bench as time moves on. Johnson loves to show off his wood project: as bottles are released, any leftovers hang

around in the tasting room. Always check the bottle cooler, as oftentimes Green Bench has bottles left of Your Silent Captain Apple Brandy Barrel Aged Cherry Imperial Stout or any of the Russian Mail Order Bride Imperial Stout Series (four variants were released at once).

In addition, Green Bench signed distribution in 2015, so bottles of some of the brewery's specialty beers will be heading out of St. Petersburg. Bottles like Oak Fermented Sour Farmhouse Blend 1, 2 and 3 will be available in select bottle shops. These beers are unique—Blend 1 is a rye saison blended with Golden Sour prior to being aged on

One of Green Bench Brewing Company's oak foeders. Green Bench ferments some of its Belgian beers inside these oak foeders. *Author's collection.*

nasturtium, dianthus, pink sage blossoms and marigolds. Blend 3 is Saison de Banc Noir blended with Golden Sour prior to being aged on locally roasted coffee and vanilla and then bottle conditioned on brettanomyces. These beers are nuanced and complex, with many subtle flavors throughout the profile.

Green Bench Brewing Company boasts one of the largest tasting rooms and one of the only lawns in downtown at its outdoor beer garden. The brewery has a beautiful space and blends industrial chic with the outdoors, a pool and a grassy knoll sensation. The brewery is a great place to hang out for a few hours, get a beer before a Rays game or just get a growler to go.

Rapp Brewing Company
10930 Endeavour Way, Suite C, Seminole, 33777
(727) 692-7912

Greg Rapp is an award-winning homebrewer who went pro and never looked back. Greg was one of the founding members of the Pinellas Urban Guild of homebrewers and still helps the guild. He now has a few others

Rapp Brewing taproom. *Author's collection.*

joining him in the brewing endeavor. Greg has developed a local and, in some cases, national following for his diverse repertoire of craft beers.

Greg Rapp has especially made a name for himself in a unique style of beer: a gose, or a German wheat ale brewed with salt. While other craft brewers set themselves apart from the fold by working on widely accepted styles, Rapp has established his reputation by keeping stocked on a love-it-or-hate-it style of beer that is citrusy, saline and slightly sour. The beer has a following, and Rapp releases bottles of the beer from time to time. Aside from his gose, Rapp has also made several dozen styles of beer in the brewery, with a select few released in bottles, but beers like Rapp's peanut butter stout or hazelnut porter or broyhan sour beer do not see distribution outside the tasting room.

One of Rapp's beers that has a cult following is Rapp's OMG Strong Ale. While each incarnation of the beer is slightly different, it usually clocks in at about 20 percent ABV. Rapp sells the beer at special bottle releases, announced periodically through social media. While Rapp's beers are distributed throughout a small area, mostly surrounding the brewery, the mother lode of beer is always to be found at the tasting room, with rarely the same beers available during consecutive visits, even over adjoining days.

Pair O' Dice Brewing Company
4400 118ᵗʰ Avenue North, Suite 208, Clearwater, 33762
(727) 755-3423

The idea for Pair O' Dice Brewing came from Ken and Julia Rosenthal, a husband-and-wife team of brewers and beer lovers who sought to bring a portfolio of fresh and hop-forward beers to the Tampa Bay area after sampling fresh and hoppy beers from markets like San Diego and Austin.

The Rosenthals began their brewing careers at Anheuser-Busch breweries but left to pursue careers in engineering. Both Ken and Julia have degrees in engineering and wanted to use their degrees. After a few years in the engineering field, the smell of hops and the potential of being business owners drew them back to their Floridian roots, but not before a stopover in Austin, Texas, helped advance the couple's dream of owning a brewery. Those dreams got bigger as the Rosenthals traveled the West Coast of the United States, all the while enjoying fresh, aromatic, hoppy ales that cities like San Diego and San Francisco specialize in making. These beery adventures led the Rosenthals back to their southern homes and the Tampa Bay brewing community in the hopes of bringing aggressively hoppy beer with them.

Exterior of Pair O' Dice Brewing. *Author's collection.*

Their past experiences shaped the future of what would become Pair O' Dice Brewing, a play on both their team effort as a couple and their idea of paradise. While at Anheuser, Ken and Julia grew and learned lessons regarding the importance of batch consistency. In Austin, they learned the value of experimentation and brewing the beers that a brewer enjoys. In Florida, they learned to carve out a niche in the community for hop-forward beers at a time when many breweries were making one or two hoppy beers but not making hops their calling card.

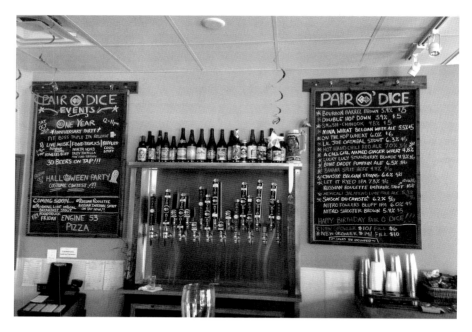

Interior of Pair O' Dice Brewing. *Author's collection.*

Pair O' Dice Brewing focuses on making the best hoppy beers that it can. That mission comes out of the taps in three core beers and numerous seasonal offerings. The core three that Pair O' Dice pours are Hop Bet Red IPA, the grassy and piney caramel red that shines both in malt and in hops; Nina Wheat Ale, the wheat ale that shines with orange peel and coriander in addition to the bready background flavors; and Lil' Joe Oatmeal Stout, the roasty and chocolatey stout that is just that: a 6 percent stout that will play well with food and satisfy the stout enthusiast.

Pair O' Dice also offers a number of rotating taps, with all house beers on in the tasting room. Its first offering, Parlay Pale Ale, is now a taproom exclusive, as are some of its more eclectic beers like Banana Split Hefeweizen, Smash Chinook or something else along those lines. Pair O' Dice doubled down on hoppy beers, and its limited-release beers include the Stickman Double IPA, clocking in at a whopping 9.5 percent, and the Pit Boss, a 13.7 percent bruiser of a Triple IPA.

Pair O' Dice Brewing is not without its secrets, especially when it comes to water and ingredients. Ken is very honest about his IPA and its ingredients— just not the water profile. Ken uses Pinellas County water to make his beers but adds minerals and salts to achieve his target water profile. Pair O'

Dice's most award-winning beer is also its most challenging. Lucky Lucy Strawberry Blonde Ale is made with 350 pounds of Plant City strawberries in every fifteen-barrel batch. This brings a strong strawberry flavor and an authentic one, since the brewery refuses to use syrups or extracts.

Pair O' Dice is showing its cards when it comes to hop-forward ales and lagers. Its Hop Streak series is designed to allow Floridians to enjoy hop-forward beers as they were intended to be enjoyed: bright, aromatic, balanced and *fresh*. During every month of 2015, Pair O' Dice Brewing will release into distribution a new beer in the series. The high-frequency, single-batch, hop-forward beer series encourages distributors, retailers and consumers to drink hoppy beers at their freshest.

The brewery has grown in leaps and bounds since opening on Halloween 2013. From pouring in its tasting room only, Pair O' Dice is currently available in five counties around Tampa Bay, with plans to expand farther into Florida in the coming year. While the Rosenthals have grand plans for Pair O' Dice Brewing, none of them involves distributing beyond Florida's borders.

Barley Mow Brewing Company
518 West Bay Drive, Largo, 33770
(727) 584-7772

Barley Mow Brewing started with owner Jay Dingman learning to love craft beer after moving to Boulder, Colorado, and his roommate brewing at Left Hand Brewing Company in Longmont. After meeting his future wife, who was also very interested in beer, the two became a brewing pair. Both of the Dingmans (Dingmen?) aimed to brew more and work less, getting each other presents for birthdays and anniversaries that had to do with brewing. Finally, the couple found that they were keeping the house at a constant sixty-eight degrees in order to ferment ales properly, and they decided that they both wanted to be fully involved in the beer industry.

Once the couple committed to craft beer, they began Barley Mow Brewing Company, and the rest is history...almost. The paperwork did not come through in time, so the brewery first opened as a craft beer bar in an old Irish pub in the Largo area of Pinellas County. The brewery and the pub/tasting room were one and the same and did not serve food. Barley Mow poured its first craft beer in November 2011 and its first Barley Mow beer in July 2012. Once the brewery was operational, Jay and his wife, Colleen, ran into a space issue. Every inch of the space that

could house a tank or vessel was housing a tank or vessel. They added a half-barrel brewing system to their already maxed two-barrel brewing system to keep up with demand once they started making Barley Mow beer. They distributed to only about nine accounts in Pinellas County at the beginning, but the facts were undeniable: this business model was not going to advance Barley Mow to its fullest potential, especially since Barley Mow would have to choose between brewing beer and seating customers due to lack of space.

Fast-forward three years down the road, and Barley Mow has found the answer to its space problem: more space. In late 2014/early 2015, Barley Mow opened a production brewery offsite from the tasting room, around the corner in Largo. This uses a thirty-barrel brewing system and has propelled Barley Mow into distribution far outside Tampa Bay. Dingman quickly employed a brewing team after the expansion. While Dingman is still the head brewer, he hired Brian Black to head up brewing operations at the Barley Mow tavern, as well as Brent Morgan and Lance Shipley to help him brew at the new production facility.

Barley Mow has adopted the mantra of "Simple. Honest. Craft." It carries that motto into everything the brewery does. The brewery encourages local homebrew clubs to meet at the pub; it hosts artists, authors, musicians and even burlesque shows. Since Barley Mow is Largo's only craft brewery, it does carry the fire of craft beer in this area of Pinellas County, extending that light north almost to the Georgia border.

Barley Mow's beers have a manner and reputation all their own and have cultivated something of a following in the Bay area. Barley Mow, itself named for a Gaelic ode to the harvest, draws inspiration and names of core beers from eclectic sources. Barley Mow's flagship beer, the Unkindness Black IPA, draws its own name from the collective name for a group of ravens. The Quackalope, Barley Mow's best-selling IPA, is named for a statue hanging in the bar of a cross between a duck and an antelope. A selkie is the name of a creature that looks like a seal in the water but assumes human form on land; it's also Barley Mow's herbal Belgian Rye Pale Ale. Finally, a maven is an expert in a given field of study, as well as Barley Mow's milk stout. Barley Mow also rotates through several seasonal and limited-rotation beers— everything from a jalapeño ale to a pumpkin porter and a hoppy barley wine are all available in good company throughout the year. As of summer 2015, Barley Mow is not packaging beer outside of kegs, so every offering is either in a growler or a keg.

R Bar Brewing Company
245 108ᵗʰ Avenue, Treasure Island, 33706
(727) 367-3400

R Bar Brewing Company is the first craft brewery in the Treasure Island area in Pinellas County, beating Mad Beach by almost a year.

R Bar is located in a building that housed a fast-food restaurant in a past life. When Bob Hughes bought the bar in December 2011, he began renovating the space and making small improvements that would help the bar stand out in the Treasure Island area. One item that immediately stood out to Hughes was the idea that he had a cook who knew how to make beer. Fast-forward three months, past dollars spent for a brewpub license and the experience of a thirteen-year homebrewer in the brewhouse, and R Bar Brewing Company was born.

R Bar uses a small brewing system in the crowded kitchen, with brewer Eric Richardson at the helm. Treasure Island cycles through many tourists, and when everyone is interested in house beers, it makes for a diminished supply.

Eric has brewed several different beers on the system at R Bar; the beauty of limited size is the ability to turn over beer quickly, given ample time for fermentation. He makes a porter that he tries to keep on tap regularly, along with several different versions of pale ales and IPAs. The brewery also makes winter ales once the weather starts to turn, as well as a coconut IPA for the adventurous.

R Bar's beers are only available on draft at the Treasure Island pub, and even then they are at the mercy of thirsty locals.

3 Daughters Brewing Company
222 Twenty-second Street South, St. Petersburg, 33712
(727) 495-6002

3 Daughters Brewing is what happens when a businessman meets a chef and they both enjoy great beer and want to build community in their town. 3 Daughters is the beer-producing enterprise of Mike Harting and his wife, Leigh, combined with the brewing prowess of former chef Ty Weaver and assistant brewer Steve Buyens, both of whom were employees of Harting when Mike was part owner of BellaBrava, a bistro eatery in downtown St. Petersburg.

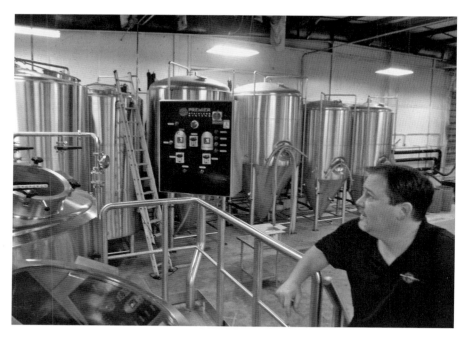

3 Daughters Brewing owner Mike Harting oversees production. *Author's collection.*

Interior of the 3 Daughters Brewing tasting room. *Author's collection.*

Weaver is the soft-spoken head brewer, responsible for turning recipe ideas into reality for the thirty-barrel brewery in an eighteen-thousand-square-foot warehouse on Twenty-second Street South. Weaver has designed the recipes that have made 3 Daughters into the local favorite it has become—from the much-consumed Beach Blonde Ale to the deeply flavorful 4 Redemption Barrel Aged Quadrupel, Weaver's stamp is somewhere in the recipe. 3 Daughters has a team that talks recipes, but ultimately Weaver's word has much to say about the beer before it becomes reality. If popularity is the measure of success, then 3 Daughters is sending beer, especially cans, all over the Tampa Bay area and in select markets over Florida.

3 Daughters Brewing has a core lineup of several different beers. The ambassadors of 3 Daughters Brewing are Bimini Twist IPA and Beach Blonde Ale. These are the two beers that 3DB sells the most of, sends the most of and drinks the most of. These beers are canned for maximum portability and go anywhere that beer (especially canned beer) is allowed to go. After the canned offerings, select draft accounts offer Stern Line Stout (also called Summer Storm Stout), an oatmeal stout full of black coffee and dark chocolate notes. Seasonally, 3DB offers Brown Pelican Dunkelweizen, 4 Redemption Barrel Aged Quadruple, Mission to Marzen and a Coffee Blonde Ale. 3 Daughters also does an occasional bottled beer release, but this is usually for a special occasion. The brewery will release bottles of Black Tip Barrel-Aged Porter, Hillbilly Highlander Barrel-Aged Scotch Ale and/or Old Number One Barleywine from time to time.

3 Daughters Brewing, like so many other Tampa Bay breweries, has an eye out for the community as well. The brewery employs a full-time quality assurance lab technician, Jim Leonard. Jim holds two PhD degrees in chemistry and works at 3 Daughters Brewing to help the beer community and to stay active. With Jim's help, 3 Daughters Brewing and the greater Tampa Bay beer community are working to begin a degree program through the University of South Florida to train brewing personnel. The program is still developing, but it is growing at a promising rate. While in the lab, Jim is also working on a program for homebrewers to schedule appointments to have their beer analyzed, as available.

Saint Petersburg Brewing Company
544 First Avenue North, St. Petersburg, 33701
(727) 692-8809

Saint Petersburg Brewing Company is an old name with a new face in 2013. The brewery was the idea of brewer Tom Williams, who thought it would be ideal to get Saint Petersburg Brewing's beers to market before building the brewery. Saint Pete Orange Wheat and Pinellas Pale Ale were brought to their namesake areas and beyond into the thirsty Tampa market via contract brewing before the brewery was even approved for construction. Now, after working in a space literally around the corner from neighboring breweries, Saint Petersburg Brewing has made a place for itself in the neighborhood brewery scroll.

Saint Petersburg Brewing uses a ten-barrel brewing system, beginning operations on equipment with a history. Saint Petersburg Brewing's brewer, John McCracken, was a bit of a vagabond before joining, going to brewing school and then taking jobs on either coast of the United States before finally settling down in St. Petersburg.

Saint Petersburg Brewing brews beers for the endless Florida summer. While Pinellas Pale Ale and Saint Pete Orange Wheat remain core beers at Saint Petersburg Brewing Company, no brewery in Florida seems complete without an IPA to call its own. After celebrating their first anniversary in April 2015 with several new recipes under his belt, McCracken still enjoys his Milo IPA from his tanks. While Orange Wheat is synonymous with Tampa Bay and the eternal, infernal heat, a nice IPA quenches the brewer's thirst and keeps him working.

Brewers' Tasting Room
11270 Fourth Street North, St. Petersburg, 33716
(727) 873-3900

Brewers' Tasting Room is a brewery, bar, tasting room and stage. BTR is like going to a concert to see a beloved band and then learning that the band is holding tryouts soon. Rick Wolfe, the owner of BTR, believes in the Tampa Bay brewing community, believes in the beer and believes that "craft beer people are generally good people," as the saying goes.

This is why Wolfe founded Brewers' Tasting Room. He wanted a collaborative spot between commercial brewer, homebrewer, avid brewer

and enthusiast. The idea behind BTR is to find the best brewers from homebrewers to commercial brewers and allow them to come in and work with staff to create a beer, brew it on BTR's brewing system and, after it is ready, serve it in the tasting room. Staff then keep track of the beer and see if this is a beer that the brewery would like to brew again.

This does not mean that Wolfe will let anyone pay to play (or brew); there is an evaluation before acceptance. A potential brewer speaks to Rick about an idea and brings in a beer, and the staff along with Beer Judge Certification Program–certified judges will evaluate the beer. If the beer makes the grade, then Wolfe will pay for the ingredients and arrange to brew the beer on his two-barrel system in exchange for the right to pour the beer from BTR's taps.

Brewers' Tasting Room has no set taps, as a result of its policies and readily available guest taps. BTR will have beer from some of the best brewers in Florida, and then those brewers might even be on the schedule to brew with BTR in the near future. Any given night could see no BTR-made beers or could see as many as five or more; frequent visits can yield diverse results.

Many of Florida's up-and-coming brewers have brewed with Wolfe and his crew. Miami brewer Johnathan Wakefield came and brewed with Rick before opening his brewery in Miami. When New Belgium launched its beers in Florida, staff from the brewery stopped in and made a beer with Rick. When Cigar City owner and homebrewer Joey Redner talked with Intuition Ale Works owner and brewer Ben Davis, the two came to St. Petersburg and brewed a beer with Rick. The fact that a place like Brewers' Tasting Room can exist in Tampa Bay is a testament to the talent, the open mind and the spirit of community on both sides of the water.

Mad Beach Brewing Company
12945 Village Boulevard, Madeira Beach, 33708
(727) 362-0008

Mad Beach Brewing Company is the offshoot of the Florida Winery and the experiment of brewer Matt Powers. Powers is a homebrewer and winemaker who ventured into the beer world to slake his love for craft beer and help others discover the varied flavors that exist within beer. Mad Beach, so named for the brewery's hometown of Madeira Beach, is in an area replete with tourist traffic during the season, and when turned back over to locals, it is a tropical destination with breezes and beers mixing like sweetest perfection. Until the end of tourist season, there is always the parking garage.

The interior of Mad Beach is a tasting room and gathering place that is meant to share the community with people. Powers said that the design of the bar (a U shape) and the large communal tables prevent anyone from isolating when the brewery is crowded. The facility has a music stage and is about six thousand square feet of tasting space, with about one thousand square feet of brewing space. Powers has plans for this place—he wants to build out a kitchen and make local food to go with the beer he makes on site. That plan is down the road, as the brewery is growing and brewing operations began in December 2014.

The beers of Mad Beach are as diverse as the visitors to the namesake beaches. Mad Beach's core offerings are in a bit of a flux as Powers figures out which beers will anchor the lineup, but so far it looks like Life's a Beach Orange Blossom Honey Wheat Ale, Dolphin Drool Pale Ale and Kaptain Kölsch Ale will be most readily available since they are so aptly suited for the Florida summer. While Powers can brew higher-gravity beers, he likes to have beers on hand that are accessible to everyone. Onward from those three beers, Mad Beach offers a vanilla coffee stout dubbed HMB Stout (thin, dark and roasty with hints of vanilla); I Yam What I Yam, a sweet potato ale (think sweet potato casserole meets marshmallow topping with graham crackers on top); several ciders and meads; and a double IPA dubbed Octohopopus. In addition to beers, meads and ciders, Mad Beach also pours wines from the sister operation downstairs.

Mastry's Brewing Company
1462 Sixty-sixth Street North, St. Petersburg, 33710
(727) 344-3837

Mastry's Brewing Company, begun by Bernie Moran and Matt Dahm, is an example of a brewery that has teamed up with a restaurant—Mastry's and the brewery's beers are only available at C.D. Roma's Restaurant in St. Petersburg. Bernie is a homebrewer who has a passion for craft beer, and Matt is a native St. Petersburger who loves craft beer and has a background in engineering that helps him to craft Mastry's beers.

Mastry's is still a young brewery with an evolving tap list, but after pouring the first house beer around St. Patrick's Day 2015, Moran and Dahm continue to crank out new beers, like Mastry's Honey Basil Ale, Low Gluten Stout, Grapefruit IPA and Strong Scotch Ale. Along with the Grapefruit IPA, Mastry's continues to bring fruit and variable flavors into its

beers. In the fermenters after less than a month of being open are Lebanese Starfruit saison, Black Imperial IPA, Warrior IPA, Tiramisu Dessert Stout and Strawberry Blonde Ale. All of these beers coming through the taps of one restaurant brewery make for an interesting flavor profile to work with the food on the restaurant side of the house. Look for more varied beers as Mastry's ferments out different beers for its St. Petersburg home.

Pasco County

Big Storm Brewery
2438 Merchant Avenue, Odessa, 33556
(727) 807-7998

Big Storm is the little brewery that could in the Odessa area of Pasco County. It's the original Pasco County brewery, with one new addition since opening. Begun by two friends, the brewery's tasting room opened in September 2012, and the brewery and its beers are gathering like, well, a storm.

Two alumni from the University of South Florida got together and realized that they had great ambitions and did not care for their day jobs. Clay Yarn and Mike Bishop were working by day and getting together to share beers at night. They decided that there existed a perfect storm of conditions in their lives, and so they put together a business plan to start a brewery. The pair looked all over for real estate—each space had a new and different challenge—until a fateful visit to an Odessa industrial park. A July 2012 launch was set, and the pair have not looked back since. Bishop and Yarn knew that they were destined for expansion, so they built the brewery with existing drainage and preparations in place for when the brewery grew. And grow it did. Fast-forward to 2015, and the brewery is bursting at the seams with space at a premium in the formerly cavernous warehouse. Fermenters and a crowded tasting room now occupy the space where once stood lone brew pots and a single bustling brewer. Now the brewery has a sales force and a new brewer in former Dunedin Brewery brewer Norman Dixon. With Dixon and Bishop at the helm, the brewery won several awards at the 2015 Best Florida Beer Competition and shows no sign of losing momentum.

The beer that built Big Storm is an amber ale, dubbed Wavemaker Amber Ale. It's a bit of a malt bomb, and at 5.6 percent ABV, this beer may make waves but does not grab with the undertow.

While Big Storm Brewery started small, it is picking up steam around Tampa, and the fifteen-barrel brewing system is being worked like the starship *Enterprise*. Its beer has won accolades from the Best Florida Beer Competition, and brewer Mike Bishop won a scholarship to the Siebel Institute of Brewing from the Florida Brewers' Guild based on the merits of his beer. With beer being distributed around the state of Florida currently, the sky seems to be the limit for Big Storm.

Look for Big Storm to expand into the Seminole area of Pinellas County in late 2015/early 2016. The brewery already announced expansion plans: the Odessa brewery is moving across the industrial park, and a second facility will open its doors in Pinellas County.

Escape Brewing Company
9945 Trinity Boulevard, Trinity, 34655
(727) 807-6092

Escape Brewing Company is the second craft brewery to grace Pasco County with its presence, but it's located in the Trinity area, miles from the Storm. Owned and brewed by two brothers-in-law, Jon McGregor and Matt Thompson, Escape Brewing is working to provide an escape from the ordinary for those who live near Trinity. Escape Brewing has only been open since late 2014, and in the spirit of collegiality, one of the first orders of business after setting up its own brewery was to brew a team collaboration with its relative neighbors at Big Storm.

Escape has received a warm reception from the Trinity area it calls home. In response, Escape has already set up a mug club for locals who are interested in staying up with the various beers the brewery makes. Escape is currently open four days each week and is only available on tap at the brewery and select local establishments. The brewery is very small, and McGregor and Thompson brew on a three-barrel brewing system, meaning that only three barrels of Escape beer are made at any given time. Even with a small-batch brewing system, the brewers do their best to keep six to eight Escape beers on at all times, including cores like Goofy-Footed Wheat Ale, Diversion IPA, Indiscretion DIPA and a brown ale dubbed Brown Chicken Brown Cow. Escape is making the most of this diversion of a brewery—so named for its ability to help McGregor and Thompson escape from the monotony of jobs outside the beer industry.

SARASOTA

JDub's Brewing Company
1215 Mango Avenue, Sarasota, 34237
(941) 955-2739

JDub's Brewing Company is what happens when a dreamer wakes up and realizes that his passion can motivate others. JDub's Brewing Company owner Jeremy Joerger ("JDub" himself) had a lucrative day job—a government job in Washington, D.C.—a steady income and a baby on the way. He put all of that on the line in a leap of faith to realize a dream for beer for the Sarasota and Greater Tampa Bay area.

Joerger soon put his money where he wanted beer to be and traded his suits in for boots, flip-flops and shorts when he moved from D.C. to sunny Florida on the promise of making quality, innovation and culture with a brewery all his own.

That dream plus a ten-year love of homebrewing led Jeremy on a path to open JDub's Brewing Company. The brewery uses a fifteen-barrel brewing system that does not have automation, meaning that the brewer has to stir almost 450 gallons of boiling brew at a time with a huge brewer's paddle (imagine using a canoe paddle to stir a small lake). All of JDub's beers are brewed the hard way, using old-fashioned elbow grease where others might have the aid of a machine. Head brewer Tom Harris, formerly of Long Trail Brewing Company, teams up with Joerger for the brewing prowess and a no-holds-barred approach to making beer. From this melding of the minds come core canned beers like Poolside Kölsch and Up Top! IPA. These are the two of JDub's beers that have seen the widest distribution, but at the source, new flavors are always on draft. JDub's tasting room has the drafts pouring everything from a sour wheat raspberry ale to a Belgian imperial stout with hints of chocolate and fruity coffee, a Honey Habanero Alt and a Foxy Brown Ale with notes of toast and toffee. As long as it is not boring, JDub's is tapping it fresh.

JDub's beers can be found all over Central Florida currently, with thoughts of organic growth growing like mangoes in the south Florida spring. JDub's brings great beer, a new limited beer tapped every Sunday, two solid canned offerings and a street team that does community service to its Sarasota home, thus doing its best to take the idea of a neighborhood brewery to a new level.

JDub's Brewing showing the humor of the craft brewing industry. *Author's collection.*

JDub's Brewing Company logo. *Author's collection.*

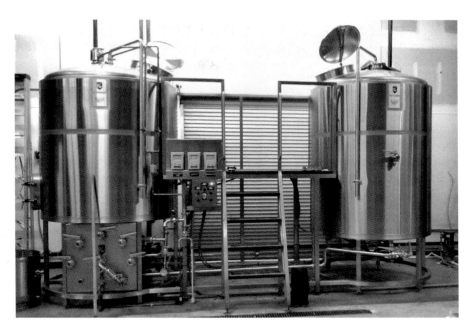

JDub's Brewing's system. *Author's collection.*

Sarasota Brewing Company
6607 Gateway Avenue, Sarasota, 34231
(941) 925-2337

Sarasota Brewing Company is a neighborhood brewpub with house beers on tap, as well as beer from other micro- and macrobreweries around the country. The homey décor welcomes families, beer enthusiasts and be-jerseyed sports fans all in the same environs. This neighborhood hangout happily shows the game on many surrounding TVs and also offers house beer for a change of flavor or more of the same, depending on a patron's preferences.

Vince Pelosi, the brewer, came on board at Sarasota Brewing in 1999 and has not looked back since. Pelosi makes beers that he is proud of, beers that represent many diverse styles. SBC's light lagers will pair well with sporting events, as the light body and relatively low alcohol volume will allow for several beers over the course of a football, baseball or basketball game. Some of SBC's heavier beers will do well with birthday celebrations, a grown-up night out or a visit with an old friend. While most of the beers in Sarasota Brewing's bag of tricks come in at a relatively low and sessionable ABV, beware the occasional

strong ale that Pelosi makes. These special occasion sippers include a Winter Quadruple and an Oats and Honey Strong Ale, among others. They have a great taste but carry alcohol content up to 10 percent.

Sarasota Brewing has been pouring in Sarasota's Gulfgate neighborhood since before the craft beer revolution and has the stuff to maintain it for a while. With several craft beer bars in the area and new craft breweries opening in Sarasota, Sarasota Brewing is helping to make the area a beer destination.

Big Top Brewing Company
6111 B Porter Way, Sarasota, 34232
(800) 590-2448

Big Top Brewing Company began brewing operations in May 2014, opening briefly beforehand. Big Top Brewing Company took a village to open, but brewer Josh Wilson and CEO Mike Bishaha combined Sarasota's history as the winter home of the Ringling Circus with a list of beer recipes; Big Top Brewing came to fruition soon thereafter.

Big Top opened with a mission help expand Sarasota's reputation as a destination with great beer. Plenty of that beer will come from brewing on Big Top's 30-barrel brewing system and 150 barrels of fermentation capacity at opening. Keeping the circus taps pouring are the ringmasters of the show: the hoppy Circus City IPA, the limey Key Lime Wheat Ale, the bready White Sands Wheat Ale, the primer for bitterness Suncoast Pale Ale and the lemon and coriander Trappeze Monk Belgian Wit. In only a year of operation, the brewery has asked the public for help with bringing some of its ideas to beery fruition. Some of the off-the-trapeze ideas for Big Top beers have been Brewed Awakening Coffee & Caramel Breakfast Stout and State Fair Stout (Chocolate & Peanut Butter Pretzel), along with Ashley Gang Double IPA and 6111, a smoked porter.

Big Top's tasting room is visible from the highway, heading north or south on I-75 through Sarasota.

Motorworks Brewing Company
1014 Ninth Street West, Bradenton, 34205
(941) 567-6218

Stepping out of the car at Motorworks Brewing Company gives an idea of the scale of this operation. The brewery itself is owned by husband and wife

Frank and Denise Tschida and is run by a core group of people who each had a hand in building the brewery into the operation that is currently brewing and serving in one of the largest craft breweries in Sarasota/Bradenton.

Inside the Motorworks tasting room is a three-thousand-square-foot room based on hospitality and introducing folks to great beer. The tasting room always has thirty drafts and one hundred bottles of beer available and strives to keep at least twenty of those lines filled with Motorworks beers of all kinds. Outside, Motorworks boasts one of the largest beer gardens in the state of Florida at thirteen thousand square feet of space, including a putting green, corn hole boards, picnic tables and bocce ball all underneath a two-hundred-year-old oak tree. The beer garden can host anything from a wedding to a chili cookoff and everything in between.

As for the beer, Motorworks is a "full spectrum" brewery, according to tasting room manager Barry Elwonger, brewing and pouring everything from light and delicate lagers to bold and heavy stouts. The tasting room staff can pour for all manner of beer folks, from those who have not had the right beer yet to those who are familiar with all styles. In fact, if someone does not like beer, tasting room staff try a game to see if that person might like something from the taps, and if not, the brewery still has a full liquor bar.

As for the beers themselves, Motorworks has a core lineup and numerous other beers to augment the flavors not covered in that lineup. The goal of Motorworks Brewing Company and head brewer Bob Haa is to bring fantastic beer into the beer community and build up that community. Starting engines at Motorworks is the best-selling V-Twin Amber Lager, a toasty and caramel lager that won a bronze medal at 2015's Great American Beer Festival and has been a crowd pleaser. This one is also slated for cans, beginning shortly after April 2015. Next in line in the core group is Indy IPA. Indy IPA is named for the independent nature of Motorworks and the love of Indy racing that many employees share. This fresh and mildly bitter IPA is also slated for cans as soon as the canning line is complete. From there, Motorworks has Roll Cage Red Ale, the light and slightly floral Cruiser Kölsch, the coffee-forward Midnight Espresso and the coffee-free version, Pit Crew Porter. These are just the core lineup. Motorworks has raced through many different styles of beer in its first year of brewing— everything from a light and floral lavender ale to a big, rich Citralicious Triple IPA and a Carrot Cake Ale made in honor of its anniversary. Motorworks has also made and bottled two beers in 750mL bottles: a barrel-aged barley wine called Thresher and a Tamarind sour named Tami. Both were only available at Motorworks tasting room.

Darwin Brewing Company
803 Seventeenth Avenue West, Bradenton, 34205
(941) 747-1970

Darwin Brewing Company started off in the confines of the Darwin's on Fourth Brewpub in Sarasota. The brewpub system has now moved to the brewery, and the Bradenton brewery is making all of Darwin Brewing Company's beer. This production brewery will be where the magic begins for the core brands of Darwin Brewing Company, so named for chef and founder Darwin Santa Maria. Darwin Brewing's beers will house the fifteen-barrel production brewing system that brewmaster Jorge Rosabal will use to slake the thirst of Sarasota's and Bradenton's beer enthusiasts. The core lineup coming through the production facility will be the grapefruity Summadayze IPA; Charapa Spiced Porter, roasty and dark with hints of pepper, honey and cacao; Ayawasca Belgian Strong Ale, toffee, malt, hint of fruit and hint of chocolate; Circa 1926, a refreshing wheat ale made with sweet tangerines; and Pirata Pilsner, a Pils brewed with grassy noble hops.

The bustling taproom at Darwin Brewing Company. *Author's collection.*

Right: A pint of Darwin Brewing Summadayze IPA. *Author's collection.*

Below: A bartender at Darwin Brewing Company pouring an Andean-inspired beer. *Author's collection.*

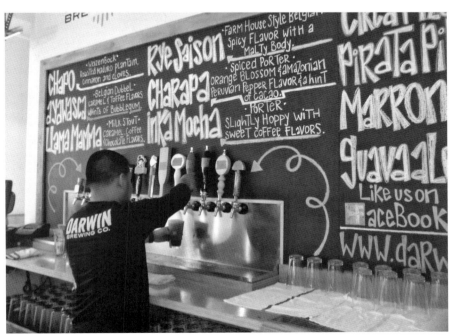

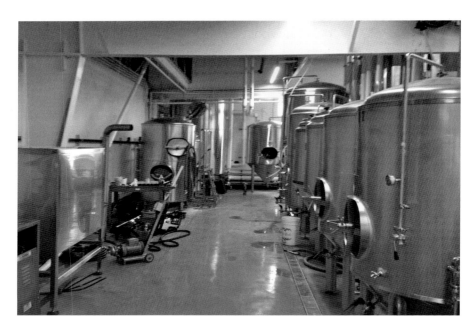

Darwin Brewing Company's production equipment in the Bradenton brewery. *Author's collection.*

Darwin Brewing is not content to merely open a new brewery; it plans to tap the potential of the new space. Canning should arrive before too long. There is already space set aside for the canning line near the brewery's loading dock and cold storage. Darwin's future plans will allow it to be one of the fittest breweries, as all warehouse space can be converted to brewery use. Rosabal said that leftover space can be used for a second brewhouse, additional fermentation tanks and a second boiler.

Jorge also plans a little something extra for patrons in the Darwin tasting room, aside from Darwin beers on tap. While beer going to distribution will be filtered, beer in the tasting room will not. It depends on beer preference. When beer is filtered, yeast and excess particulates in the beer are removed, but many would argue that filtering beer removes flavor as well. Unfiltered beer is typically hazy and can contain some yeast, barley or hop sediment. Darwin's will allow patrons to try both and decide a preference.

Darwin Brewing Company draws influence and joy from both its Peruvian influence and Andean roots. In conversation, Chef Darwin said that Peru is proud of what the brewery is doing. In fact, the brewery has

received samples of different Amazonian woods for Rosabal to age his beers in so that a little bit of Peru can truly dwell in some of Darwin's beers. While Darwin was very proud of this, both he and Rosabal were not sure of a timeline for when Amazonian wood-aged beers would be ready.

While Darwin Brewing has a bright future ahead of it, it is striving valiantly to get beer out to the markets in which it is currently distributing.

Breweries in Progress

Here's just a taste of what is in the hopper for Tampa Bay's craft beer movement.

PINELLAS ALE WORKS (PAW): Pinellas Ale Works is looking to build St. Petersburg's next craft brewery. The brewery is the project of homebrewers Matthew Brown and Derek Decker. The two are building a fifteen-barrel brewery on First Avenue South in St. Petersburg.

HIDDEN SPRINGS ALE WORKS: Hidden Springs Ale Works is the project of two homebrewers who are looking to go professional. Joshua Garmin and Austin Good have signed the lease to a warehouse space in the Tampa Heights area, two blocks east of Ulele and Waterworks Park. Garmin and Good are looking to bring bold beers to the area and solidify their core lineup of beers with an IPA, a double IPA, a milk stout and a Berliner weisse.

LATE START BREWING COMPANY: Late Start Brewing Company is the side project of professional brewers Jordan Copher, Nick Streeter and Tyler Sankey. All currently work brewing in Tampa Bay and use Late Start as their creative outlets for beers that they want to brew. The friends are seeking investors to help them start a one-and-a-half-barrel brewery in Tampa. Late Start is a regular at most beer festivals around Tampa Bay and puts on its own events with Inkwood Books, Loko Cuisine and more.

BASTET BREWING COMPANY: Named for the Egyptian goddess daughter of Ra, this nanobrewery is looking to bring a wide array of small-batch beers to Tampa. Utilizing a one-barrel pilot system and a three-barrel not-a-pilot system, Bastet Brewing hopes to bring its beers like Hop Tub Time Machine IPA, Mainly Vanilla Porter and How Now Brown Cow Milk Stout to Tampa taps as soon as possible.

URBAN COMFORT RESTAURANT AND BREWERY: The outstanding barbecue restaurant in St. Petersburg will open a brewpub when brewing operations begin. The barbecue restaurant currently has a brewpub license, and the new restaurant will have a brewery facility.

CROOKED THUMB: Crooked Thumb is a brewery under construction in Safety Harbor. The brewery is named for a geographic description of Pinellas County, saying that the area hangs off the middle of Florida's west coast "like a crooked thumb." The brewery is the dream of Kip Kelly and an investor partner. The duo is aiming for a fifteen-barrel brewery with an indoor tasting room and an outdoor beer garden. The building is moving along but is still under construction as of the summer of 2015.

CROXBONE BREWING COMPANY: Croxbone Brewing is the labor of Brian and Nicole Cendrowski. The brewery is built on a theme of exploration—exploring the nuances and various flavors of beer but also trying to put an innovative twist on everything it does. It has been pouring its Spiritu Santo IPA around Tampa at festivals and is currently working to build the brewery and the brand.

LOCAL BREWING COMPANY: Local Brewing Company is associated with the Lucky Dill Deli in Palm Harbor in Pinellas County. Currently, the bar and restaurant are operating with intentions of adding brewing facilities soon.

MONUMENT BREWING COMPANY: Monument Brewing Company is a craft brewery in planning south of Tampa Bay in the Apollo Beach area (near the manatee viewing area, southbound on I-75). While the brewery is working feverishly toward opening day, it is working on refining recipes and getting everything "just right."

TANGENT BREWING COMPANY: Tangent Brewing Company is the outgrowth of homebrewer Rodney Sedillo's love of brettanomyces and sour ales. All of the beers from this brewery will contain 100 percent brettanomyces or will be barrel-aged sour ales, or both. Small breweries of this magnitude have been showing up around the United States, and Tangent wants to be Tampa Bay's sour and wild ale brewery.

OVERFLOW BREWING: Overflow Brewing Company is two Pinellas County homebrewers showing off their unique take on craft beer. Overflow specifies that it is not a "real brewery" and has no plans for ever becoming a "real brewery"—it's just for pouring serious beers.

BAYSHORE BEER COMPANY: Bayshore Beer Company is currently contract brewing with hopes of building a brewery in the Tampa Bay area. Begun by brewer Greg Rosace, Bayshore poured its first beer while still in the searching phase of brewery building. Currently, the Ballustrade IPA and Hyde Park Pale Ale are available in six-pack bottles in areas of Tampa.

MARKER 48 BREWING: Marker 48 Brewing is working toward opening Hernando County's first production brewery. The facility, located off Cortez Boulevard, will showcase a six-thousand-square-foot brewery, tasting room and beer garden while brewing on a seven-barrel brewery.

LITTLE GIANT BREWERY: One of the most hotly anticipated brewery openings in the Tampa Bay area is Little Giant Brewery. Little Giant is the little brewery that could, and owner/brewer Michael Wagner has worked very hard to turn a warehouse into a brewery. However, several times the ground has fallen out from under him, and he has had to move locations and start again. A perennial favorite at festivals, Wagner has been pouring for years while the drinking public waits for a permanent fix. Circumstances look the best they have ever been in 2015, as Wagner appears close to finishing off his Bradenton warehouse and getting equipment in place. Once he does, Little Giant, named for Wagner's alma mater mascot, the Wabash College Little Giants, will complete a Bradenton craft beer trifecta.

HOMEBREW SHOPS/BREWERY INCUBATORS

For those with brewing aspirations or tendencies, these are the places in Tampa Bay where the pros help everyone from neophyte homebrewer to experienced competition brewer.

BOOTH'S BREWING SUPPLY: This Brandon-area store is connected with ESB Brewing, as owner Francis Booth is the "B" in ESB.

SOUTHERN BREWING AND WINEMAKING: This staple of the Tampa Bay craft beer community taught folks how to brew for so long that it decided to purchase brewing equipment and show the community how to brew the type of beers and wines that staff enjoy.

HiFi Homebrew and Barbecue Supply: The newest addition to the homebrew supply scene in Pinellas County, homebrewers Robb Larson and Lisa Schneider Colburn decided to open up a supply store in the Clearwater area to better serve those brewers who did not want to venture out so far for supplies.

Bootleggers: This is a Brandon-area homebrew supply store with twenty years of brewing experience. Bootleggers is both a classroom and a retail store; it provides brewing classes, helps put together brew day kits and provides ranger services through a forest of available hops.

Avid Brewing and Growing Supplies: This St. Petersburg–area homebrew supply specializes in brewing supplies and helping those who want to grow their own hops. This store is there to help aspiring hop growers as well as aspiring hydroponic gardeners and growers.

Local Beer Festivals

Tampa Bay is known for its diverse and ever-growing beer scene, and the area also throws some of the best festivals in the southeastern United States. Most of them have become annual traditions. While it's apparent that Tampa Bay has much to celebrate, the style and swagger with which the people celebrate is all their own.

Cajun Café on the Bayou Cider and Mead Festival (January): This festival is dedicated to fermented apples and fermented honey. If you are thinking of trying any of these styles, this is the place to wet the whistle. Many hard-to-find ciders and meads from local producers, as well as national and international cideries and meaderies, are poured at Cajun Café's annual celebration of mead and cider.

Dunedin Brewery Stogies and Stouts (February): This festival is dedicated to cigars, stouts and all manner of dark flavors. On a February night each year, Dunedin Brewery closes to the public, and all taps flow with stouts, porters and dark beers. Each participant also gets a stogie upon arrival. If you're a fan of either, this festival shows off the magic when a quality stogie and a craft stout merge their flavorful efforts.

Angry Chair Brewing co-owner Ryan Dowdle pouring beer at the Cajun Café Fest. *Author's collection.*

Dunedin Brewery exterior. *Author's collection.*

CAJUN CAFÉ ON THE BAYOU: During April, May and November, Cajun Café on the Bayou in Pinellas Park puts on several themed beer festivals. Unlike the cider and mead festival, these festivals also feature many craft beers from local producers, national producers and international breweries. Many homebrewers contribute, and many craft breweries bring their best beers to festivalgoers. April sees the Festival of Florida beers, dedicated to all Sunshine State brewers; May sees the Sour, Lambic and Berliner Weisse festival, a day when all beer is sour, tart or wild; and November sees the Fall Craft Beer Festival, where interesting beers from across the globe appear and pour for the duration of the festival. These festivals are worth the admission, as the café runs a tight ship when it comes to the festivals: few lines, friendly folks and a plate of food with every admission.

FLORIDA BREWERS GUILD TAMPA FESTIVAL: The Florida Brewers Guild Tampa Bay Festival (FBG Fest) is one of the hallmark events of Tampa Bay Beer Week. This festival is the calendar start of the week (the kickoff party is usually the night before) and also one of the most well attended. The Tampa Bay FBG Fest allows any brewer in Florida who belongs to the guild to come and pour beer for thirsty attendees. This festival is a great opportunity for Tampans to get to know the state brewing community, as brewers travel from all corners of the state to attend. Breweries from Key West to Pensacola all come to pour here, and the price of admission is a great value, allowing one to travel around the state's beers in less than the space of one park.

BEST FLORIDA BEER BREWERS BALL: The winners of the Best Florida Beer competition are announced at this annual day of celebrating the best beer from around the state. Brewers and brewery personnel are usually on hand to collect awards and take pictures, as well as drink the award-winning beers. This festival usually takes place during the first Sunday of Tampa Bay Beer Week.

GREEN BENCH BREWING PRESENTS FOEDER FOR THOUGHT: Another Tampa Bay Beer Week festival, this one celebrates sours, lambics, wild ales and farmhouse ales, many of which have been aged in foeders like the ones at Green Bench. The tap list is wide and varied, with guest taps from breweries like New Belgium, Jester King and Anchorage, just to name a few.

PEG'S CANTINA BARREL-AGED DAY: One of the most sought-after festivals during Tampa Bay Beer Week, Barrel-Aged Day takes place at Peg's Cantina in Gulfport, although there has been talk of moving it to Cycle

Right: Tampa mayor Bob Buckhorn taps the first firkin of the first Tampa Bay Beer Week in 2012. *Author's collection.*

Below: The Florida Brewers Guild Fest is hosted annually in Tampa and is full of surprises—like this three-year vertical of Intuition Ale Works Underdark. *Author's collection.*

Brewing in St. Petersburg. This is a day when every tap will flow with new and different barrel-aged beers. This one takes place during Friday of Tampa Bay Beer Week.

BERLINER/FLORIDA WEISSE BASH: Taking place in May every year, as summer is settling into Florida after a brief winter and a spring that seems like summer, Berliner Bash on the Bay began several years ago as a collaborative event between Peg's Cantina and J. Wakefield Brewery of Miami. This festival celebrates the unique Florida Berliner weisse, the fruity and uniquely colored brew made with different and varied fruits from around the Sunshine State. The year 2014 saw the event move locations to Green Bench Brewing and witnessed a name change to Florida Weisse Bash.

TAMPA BAY BEER WEEK'S HALFWAY THERE RARE BEER FESTIVAL: Halfway There takes place at the halfway point to Tampa Bay Beer Week. This

A glass of J. Wakefield Brewing's DFPF, a pink Florida weisse. *Author's collection.*

event sees the breweries that usually celebrate Tampa Bay Beer Week going all out in one afternoon, pouring forth some rare and different treatments, sours, barrel-aged brews and beers that may never be seen again. This event is a fundraiser for the nonprofit Tampa Bay Beer Week organization and helps it put on events and promote Tampa Bay Beer Week as well as it can.

BEYOND TAMPA

While the Tampa Bay area is wide, there are several areas just outside Tampa that contribute to the reputation of the area without being in the geographic confines of the counties surrounding that namesake body of water.

COPP WINERY AND BREWERY: This small brewery is one block west of U.S. 19 in Crystal River. Copp Brewery distributes to parts near its home market, and its Southern Grit pale ale, along with anything from an English IPA to a rum-aged stout, makes the rounds in the taproom. The English IPA and the True Grit are usually on tap—they have won medals in Best Florida Beer Competition in past years. A bright and airy tasting room on a hill in a little

Tasting room at Copp Winery and Brewery of Crystal River. *Author's collection.*

town, Copp Brewery is one of two craft breweries making Citrus County worth a road trip for more than manatees.

NATURE COAST BREWING (@ BURKE'S OF IRELAND): This brewery in Crystal River has some diverse offerings. After one year in operation, this small brewery in a local Irish pub is making heading north on U.S. 19 more palatable. Scorpion pepper hefeweizen, pineapple hefeweizen and a peanut butter and chocolate brown ale await. Another craft brewery in Citrus County, Nature Coast's beers are helping to put Citrus County on the craft beer map and attracting beer enthusiasts on a day trip.

SWAMP HEAD BREWERY: The original Swamp Head Brewery opened a few months after Tampa's Cigar City and has been setting Gainesville's craft beer scene apart ever since. Swamp Head crafted a reputation on the backs of five core beers: Wild Night Honey Cream Ale, Cottonmouth Belgian Witbier, Stumpknocker Pale Ale, Midnight Oil Oatmeal Coffee Stout and Big Nose IPA. While those beers built the barn, Swamp Head continued to develop new recipes until it began bottling in December 2012. In February 2015, Swamp Head completed a move and opened a brand-new 13,500-square-foot brewery down the street from the established brewery off the Archer Road exit from I-75. Swamp Head has an established core lineup of beers with Stumpknocker Pale Ale currently in cans and several other core brands to follow shortly.

ALLIGATOR BREWING AT TALL PAUL'S: Alligator Brewing is a small brewery in downtown Gainesville that blends style-bending beers with a full bar in a college town. The brewery wins consistent gold medals at Best Florida Beer Competition for its Smoked Habanero Ale, but at the brewery, brewers love to bend styles and try new beers.

FIRST MAGNITUDE BREWING COMPANY: Gainesville's newest craft brewery is named after the designation for a large spring. The brewery is the labor of love of several good friends who wanted to build a brewery and enliven a community with beer. With a blonde, a pale ale and a mild anchoring the lineup, First Magnitude is adding a worthwhile stop to the Gainesville beer map.

INFINITE ALE WORKS: Infinite Ale Works is run by the owners of Ocala's Pie on Broadway and has the distinction of being Ocala's only craft brewery. Its motto is "Traditionally Inspired and Infinitely Creative."

BREW HUB: Going the other direction outward from Tampa, Brew Hub is a contract brewing facility with house-made beers and a unique tasting room. Some of the breweries that contract-brew through Brew Hub are not readily available in the state of Florida, but through Brew Hub, patrons can taste many of the beers made at the massive brewery. Breweries like North Carolina's Green Man and Iowa's Toppling Goliath are all on tap at Brew Hub and currently nowhere else. Brew Hub has a massive fifty-thousand-square-foot warehouse off I-4, with brewing partners from around the state and the country partner-brewing at its facility.

LAKELAND BREWING: Lakeland Brewing Company is currently brewing and sending beer out into the market. It is a relatively new brewery with first distributor pickup in January 2015. Keep checking its social media pages for developments and available beers.

GLOSSARY

ale: A beer that is fermented warm and one in which the yeast ferments from the top down. Ales can be ready to serve in a few days, depending on conditions and brewer preference.

brettanomyces: Wild yeast that comes in several different strains. Each strain can impart a unique flavor on a given beer. In some styles of beer, these flavors are considered flaws. In the wine world, these are always considered flaws. In the beer world, there are several styles of beer that revolve around the brewer allowing brettanomyces into a beer to impart those same flavors. Those flavors could be anything from pineapple to earthy barnyard flavors or several levels in between those extremes.

brite tank: The brewing vessel that is the last stage before packaging. A brite tank is recognizable because it is not conical in shape.

craft brewery: A brewery so named because of its size, its ownership and its use of traditional practices and ingredients. A craft brewery, as defined by the Brewers Association, is small, independent and traditional.

fermenter: A vessel, usually shaped like a cone-bottomed cylinder, in which beer undergoes fermentation.

flagship beer: A flagship beer is usually a best-selling beer, one that has a following or one that the brewery advertises the most (e.g., La Tropical, Jai Alai IPA or Beach Blonde Ale).

IPA (India pale ale): A beer named for its color and its purpose. When British troops were stationed in India, the beer would spoil on the long voyage. British brewers would increase the amount of hops, increase the alcohol content and increase the bitterness of the beer, but the beer would survive the journey from England to India unspoiled. The most popular beer style in America.

lager (n): Also called simply "beer" in days prior to the popularity of ales. A lager is a cold-fermenting beer that finishes fermenting in up to a month or more.

lager (v): To lager something means to store it. Since lagers take so much more time to ferment than ales, newly minted craft breweries usually wait to establish a lager program.

mead: Wine made from fermenting honey. Mead comes in dozens of varieties and strengths and is one of the oldest fermented beverages known to man.

INDEX

INDEX

INDEX

ABOUT THE AUTHOR

Mark DeNote is a wandering beer writer who keeps a home in Florida and an eye on the road in search of fresh, local beer. A native Floridian, Mark is a teacher at heart and enjoys talking about beer and beer history almost as much as tasting beer. Mark is also the author of *The Great Florida Craft Beer Guide*. His work has been featured in *DRAFT Magazine* and other local publications, as well as on CraftBeer.com. He edits, reports, interviews and writes the story behind craft beer on the web at FloridaBeerNews.com.